ITHACA

ITHACA
A Book of Photographs

edited by Andrea Fleck Clardy

photographs by:

Nancy Carrey
Jon Crispin
Andrew Gillis
Kathy Morris
Jon Reis
Marilyn Rivchin
Constance Saltonstall

 McBooks Press ● Ithaca, New York

ACKNOWLEDGMENTS
 Permission to reprint excerpts from the following
publications has been received from the publishers and/or
authors and is hereby gratefully acknowledged:

25 Walks in the Finger Lakes Region by Bill Ehling (New
Hampshire Publishing Company, Somersworth, NH 03878,
1979).

Ithaca College Bulletin (Ithaca College, Ithaca, NY 14850, 1980).

Early Boyhood Days in Ithaca by Lawrence H. Jacobs (DeWitt
Historical Society of Tompkins County, Inc., Ithaca, NY 14850,
1971).

Remembering Ithaca 1930-1970 by Jessamine Kelsey Johnson
(DeWitt Historical Society of Tompkins County, Inc., Ithaca, NY
14850, 1971).

Night Stand and Other Stories by James McConkey (Cornell
University Press, Ithaca, NY 14853, 1965).

"On Being a Writer at Cornell" by James McConkey in *Arts and
Sciences Newsletter,* vol. 1, no. 1 (Cornell University, Ithaca, NY
14853, 1980).

A Finger Lakes Odyssey by Lois O'Connor (North Country Books,
Lakemont, NY 14857, 1975).

"To Ithaca" by Abby Rosenthal, first published in *The Grapevine*
(Ithaca, NY 14850).

Letters of E. B. White, collected and edited by Dorothy Lobrano
Guth (Harper and Row, Publishers, Inc., New York 10022, 1976)
by consent of the publisher and Mr. White.

"August Afternoon in Stewart Park" by Katharyn Machan Aal
was first published in *Unicorn* vol. 9, no. 3/4 (Loyola College,
Baltimore, MD 21210, 1980).

"What It's Like Living in Ithaca, N.Y." by Dick Lourie was first
published in *Anima* (Hanging Loose Press, Brooklyn, NY 11217,
1977).

Book Design by Mary A. Scott
Cover Photograph by Jon Reis
Typesetting by Strehle's Computerized Typesetting

Library of Congress Cataloging in Publication Data

Main entry under title:

Ithaca : a book of photographs.

 1. Ithaca, N. Y.—Description—Views. I. Clardy,
Andrea, 1943- II. Carrey, Nancy.
F129.I8I82 779'.9974771 80-26849
ISBN 0-935526-03-X

This book is distributed to the book trade by The Crossing
Press, Trumansburg, NY 14886. Individuals may order this book
from bookstores or directly from The Crossing Press. Please
include $1.00 postage and handling with mail orders.

Printed in the United States of America
2 4 6 8 9 7 5 3 1

This book is dedicated to all the people who have
found in Ithaca, New York, a landscape
and a community in which they felt at home.

Introduction

Ithaca invites devotion. It is a city which charms visitors with two college campuses, Cayuga Lake, extravagant gorges and waterfalls, an assortment of lovely old buildings, accessible countryside and a vibrant downtown. Ithaca is a city to which those who happen to come choose to return. It is also very much a hometown: a collection of neighborhoods in which families have lived for generations.

The photographs in this book tend to be clustered according to subject or geographical area, and to follow the sequence of the seasons. This arrangement is not inviolate, however; it is characteristic of Ithaca that the campus communities interact with the downtown, that the rural expanse is always visible just beyond the edges of the city, that warm days pop up in February and snow flurries sometimes fly in May.

The words which accompany the photographs are culled from interviews with Ithaca residents as well as excerpts from published and unpublished literary works.

This project has been a collaborative one. All the contributing photographers played a role in the gradual evolution of this book. And they printed hundreds and hundreds of photographs for consideration.

I am indebted to Sol Goldberg and the staff of Visual Services at Cornell University for their generosity in providing important photographs from their files. The Public Information Office at Ithaca College was also very supportive. Carol Kammen, local historian, offered helpful insights. I also thank Dr. Frederick Williams for identifying useful classical allusions to Ithaca, and Dr. Frederick Ahl for creating original translations for this book; these courtesies were arranged by Andrew Gillis. Nancy Carrey conducted many of the interviews with Ithacans. Katharyn Machan Aal graciously collected and helped to edit the poems by past and present Ithacans. Finally, I am very grateful to Alex Skutt of McBooks Press for his clear critical sense and his general good cheer.

Ithaca: A Book of Photographs was inspired by the Ithaca Festival, our annual community celebration of the arts. It is intended to capture some of the joy and variety and strong sense of community with which the Festival is charged. It is intended, quite simply, to celebrate the city of Ithaca, New York.

Ithaca, 1980 Andrea Fleck Clardy

As I approach Ithaca . . . the automobile seems far above the countryside, a throbbing airplane slowly descending, banking, and descending again upon some twinkling center of life. Returning home by night or day, I can see my house while I am still a mile distant: its immaculate whiteness or its gleam of lights appears, vanishes and appears again.

James McConkey
from *Night Stand and Other Stories*

Route 13 toward Ithaca

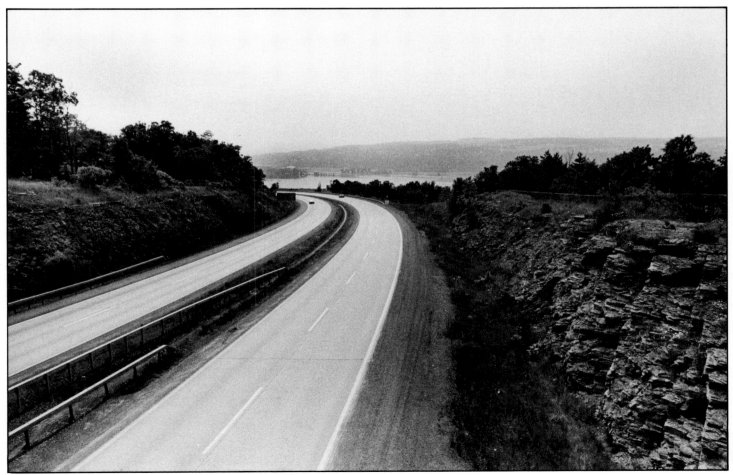

CRISPIN

. . . Our homeland should certainly give us delight. It exercises upon us a compelling force, something inborn and of such magnitude that once a man of exemplary wisdom chose that homeland of his, Ithaca — a tiny nest perched on tiny but rugged crags — in preference to a chance to never die . . .

Cicero
de Oratore 1.44.196

Ithaca

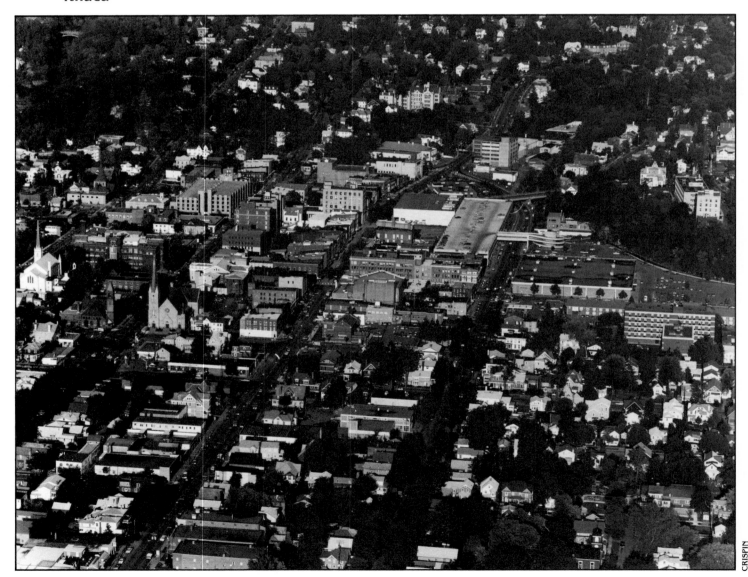

CRISPIN

"People in Ithaca are not just people —
they're our friends."

Duane Waid
Printshop owner and beekeeper

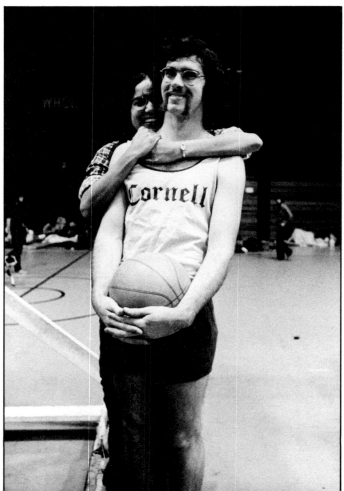

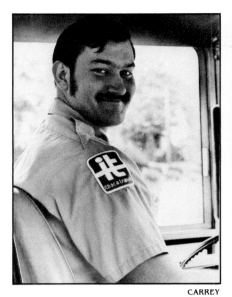

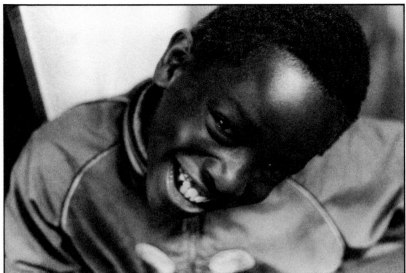

CARREY

CRISPIN

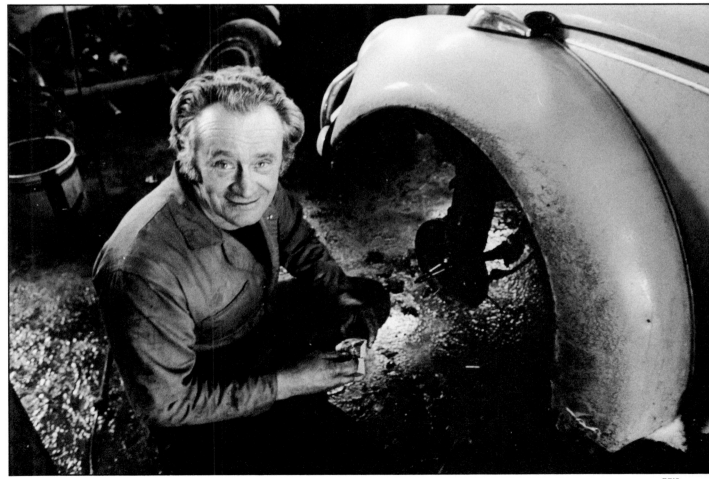

REIS

CARREY

REIS

CRISPIN

14

REIS

CRISPIN

The Ithaca Commons is a unique facility which carries with it a unique opportunity to bring life and vitality to Ithaca's downtown. It is important that the Commons become much more than an attractive commercial center; it must also be a gathering place and a community focal point where a wide variety of events and activities are permitted and encouraged to occur.

Ithaca Commons Operations Manual

Ithaca Commons, North Side

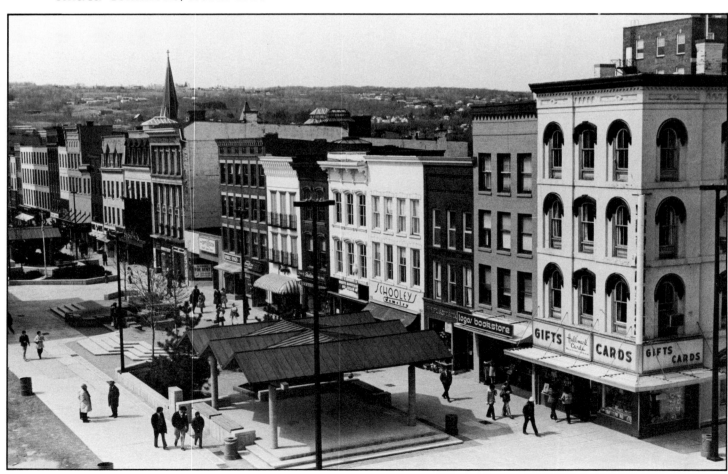

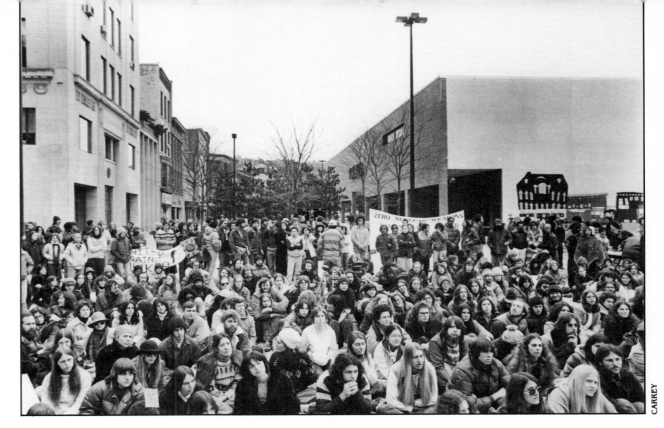

Ithaca Commons, Center

Ithaca Commons, Amphitheater

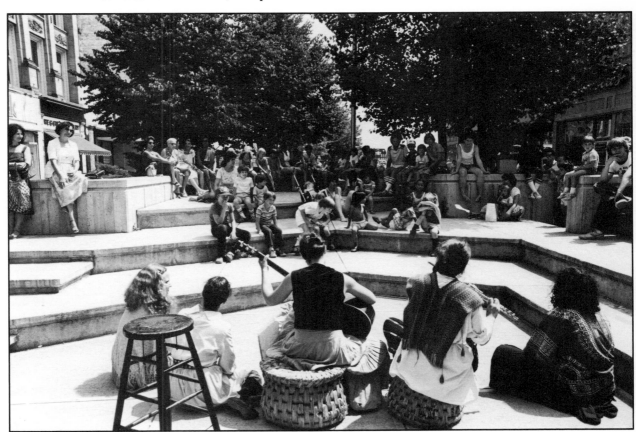

CRISPIN

CARREY

18

"The beauty of a downtown center such as ours is that all the different people in the community look at that area with pride and feel it is truly their own. The senior citizens, the young people, the merchants, families with children, and disabled persons all feel that space was designed for them. We've preserved the historic beauty of our downtown buildings and made the central business district into an area where people want to live and shop and host their activities."

Edward J. Conley
Mayor of Ithaca, 1972-1979

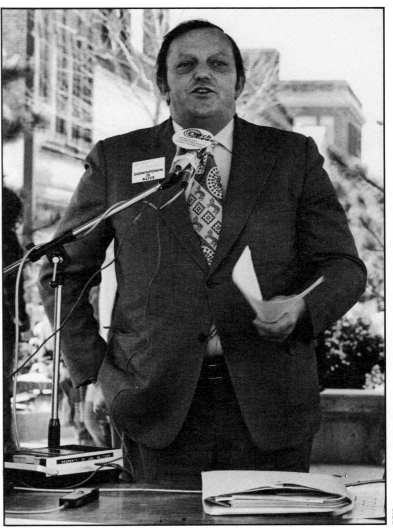

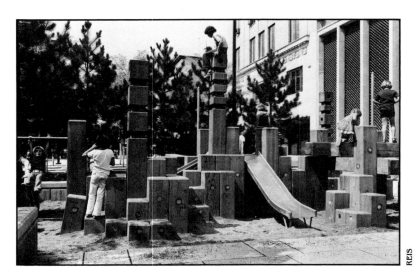

REJS

Ithaca Commons Playground

Ithaca Commons Pavement

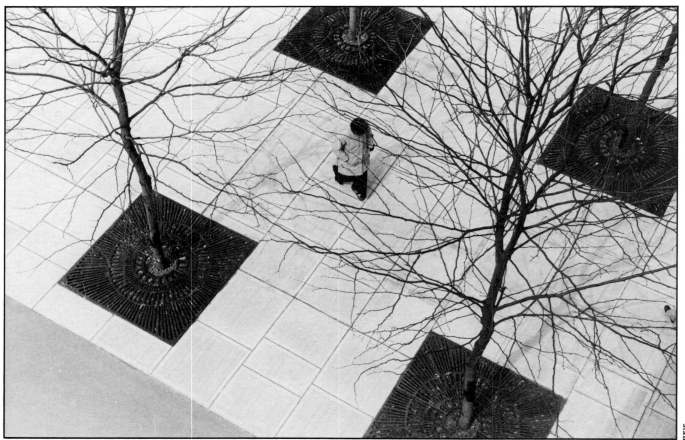

REJS

Citizens Savings Bank Building

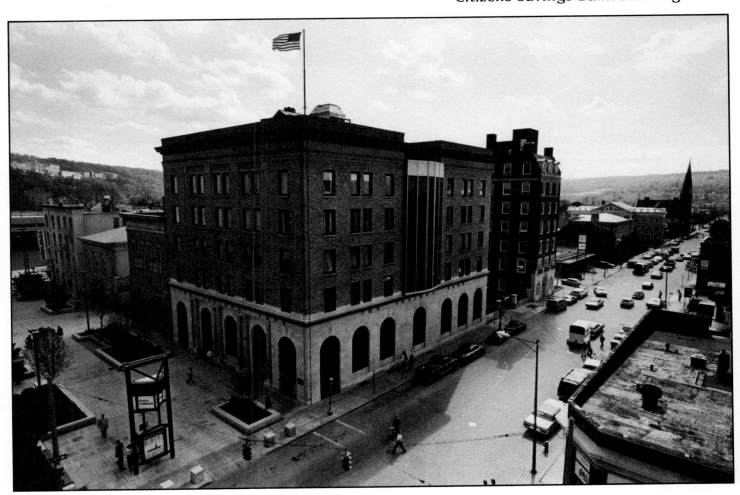

REIS

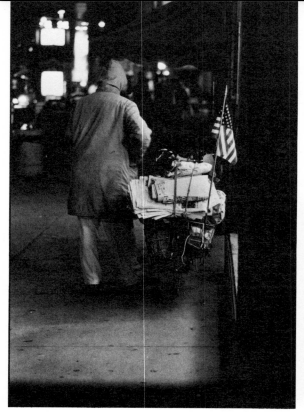

East State Street

Hotel Leonardo Pool Room

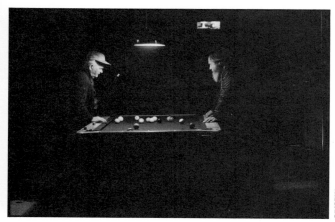

. . . all over the night
the lights of Ithaca
flashed their usual jewels.

Katharyn Machan Aal
from "From Libe Slope"

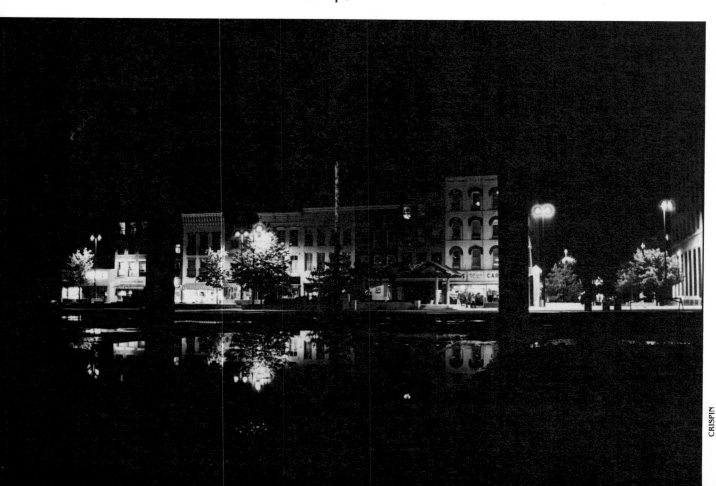

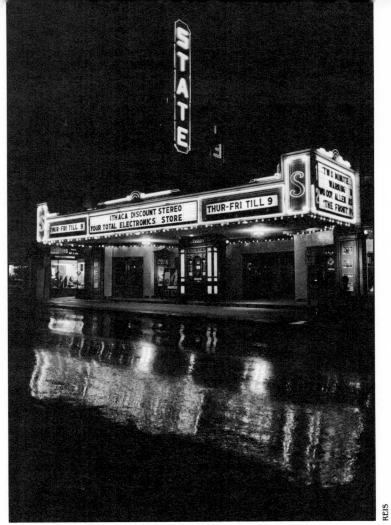

REIS

State Theater

State Theater Box Office

State Theater Interior

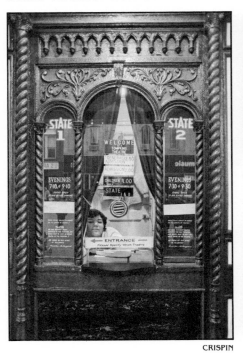

CRISPIN

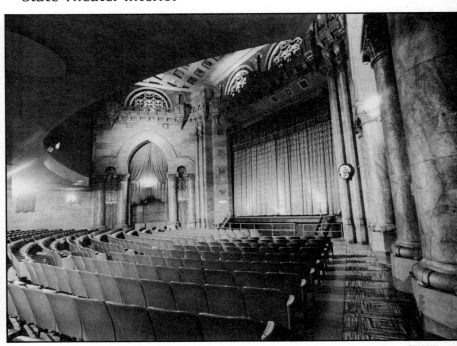

CRISPIN

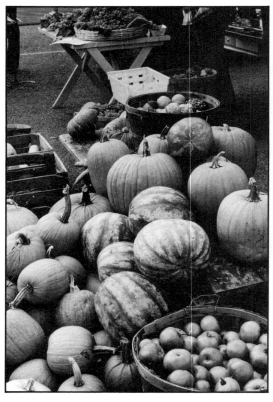

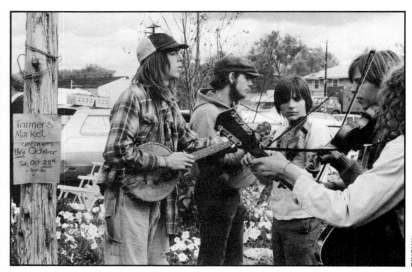

Farmers' Market, West Side

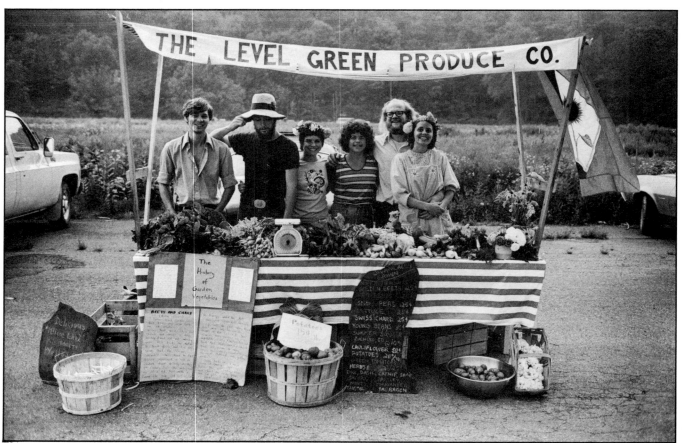

THE LEVEL GREEN PRODUCE CO.

"The Ithaca Farmers' Market began in 1974 as a handful of pickup trucks parked by a curb in the west end of town. Each year it's grown larger and now accommodates about sixty producers of fruits, vegetables, honey and other edibles, as well as products of home workshops. We're mostly market gardeners rather than farmers in the usual sense. Everything we sell has to be produced by the person who sells it and it must be made or grown within a thirty-mile radius of Ithaca. Those of us who sell have the satisfaction of offering things that are eagerly sought by a public that is tired of supermarket quality. There's a happy atmosphere at the market that makes Saturday the best day of the week."

George Sheldon
Editor, *The Grapevine*

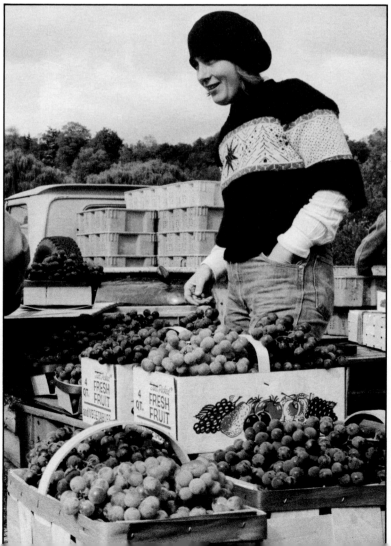

Ithaca Calendar Clock Building, Adams and Dey Streets

"Our buildings reflect the images of ourselves, our needs and desires, our values and goals. Our buildings need care and nourishment as do our bodies and souls."

Priscilla B. Dolan
Coordinator, Ithaca Landmarks
Preservation Commission

119 West Buffalo Street

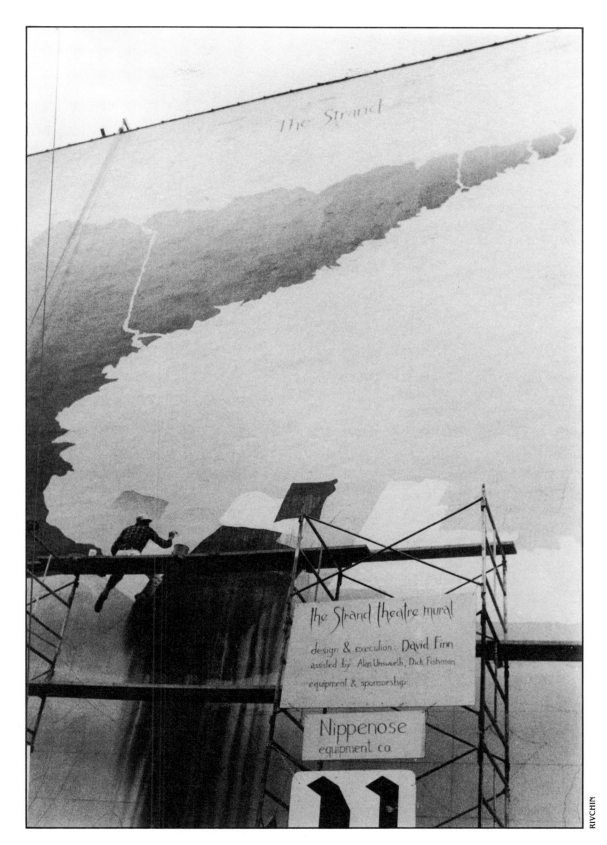

The following text appears within the photograph:

The Strand

The Strand theatre mural

design & execution: David Finn
assisted by: Alan Unsworth, Dick Fishman
equipment & sponsorship:

Nippenose
equipment co

RIVCHIN

The Strand Theatre Mural

27

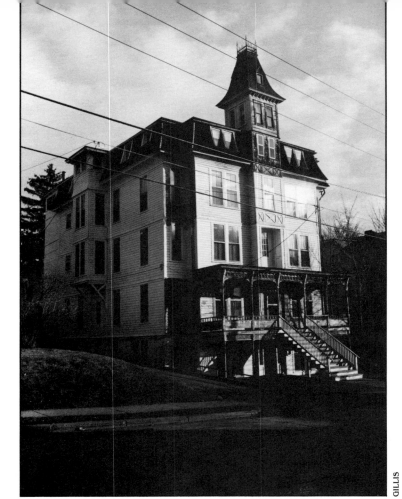

209 College Avenue

The DeWitt Building, Seneca and Cayuga Streets

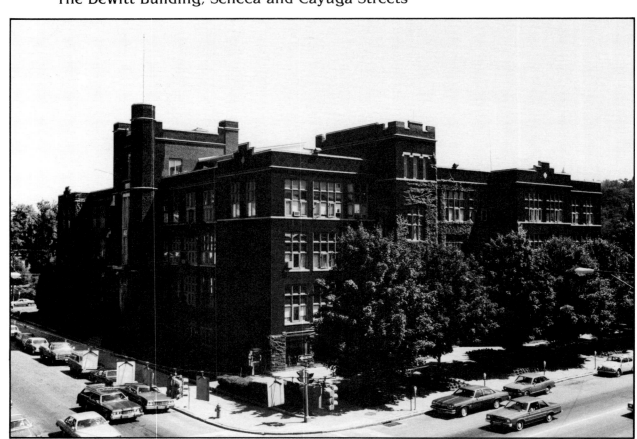

28

Detail, St. Catherine Church

MORRIS

St. Catherine Greek Orthodox Church, 120 West Seneca Street

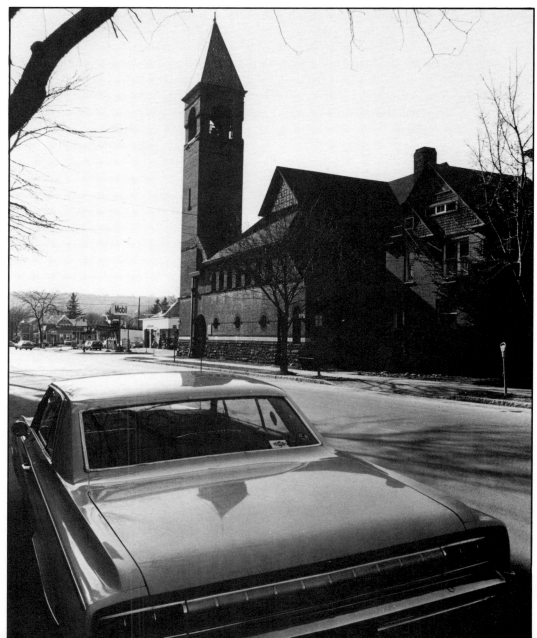

GILLIS

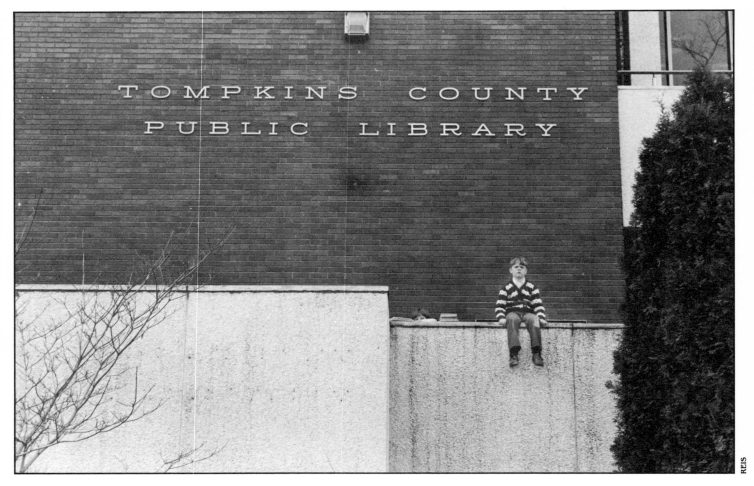

Tompkins County Public Library, 312 North Cayuga Street

McBooks, 106 North Aurora Street

PHOTO POST CARD

ADDRESS

Kodak
PLACE
STAMP
HERE
Paper

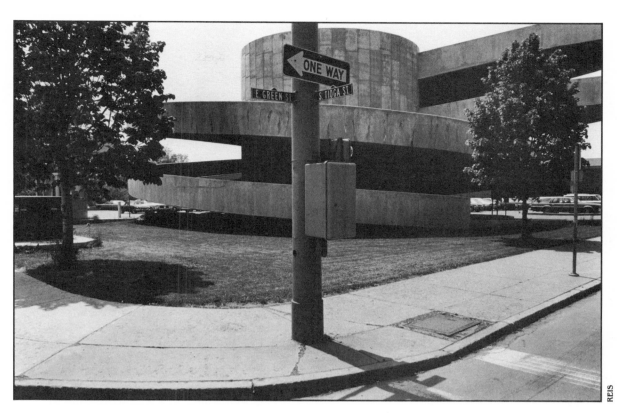

Green Street Parking Ramp Helix

Ithaca Gun Company, 123 Lake Street

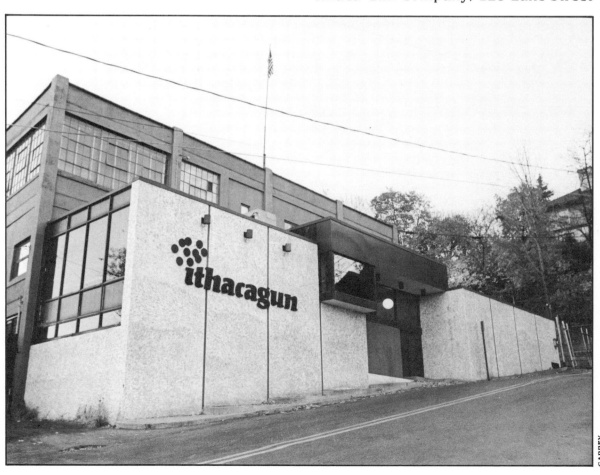

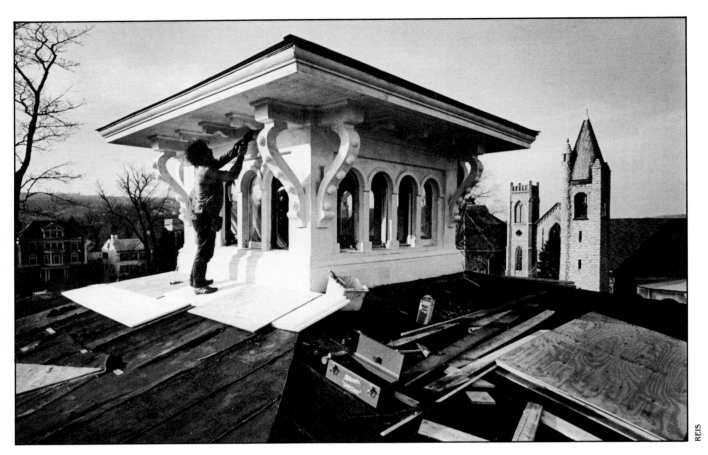

Boardman House, 120 East Buffalo Street

"Constructed in 1864, the Boardman House has served as a private home and as the administration building for the Ithaca Conservatory of Music. In 1969, it was purchased by the Tompkins County Board of Representatives, along with the other buildings of what had become Ithaca College. It has stood vacant since that time."

Carol U. Sisler
Executive Director, Historic Ithaca

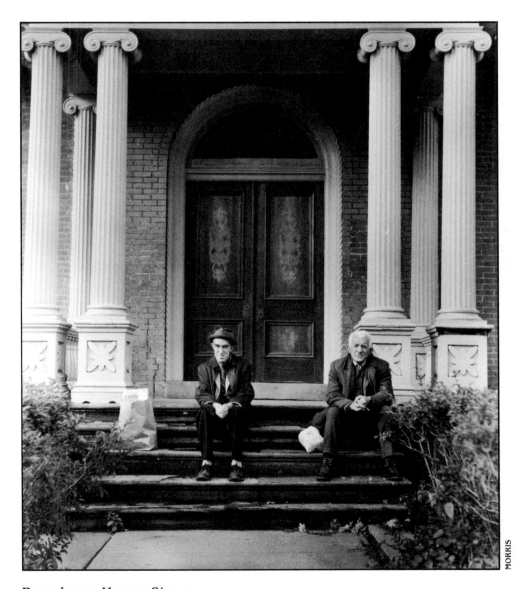

Boardman House Steps

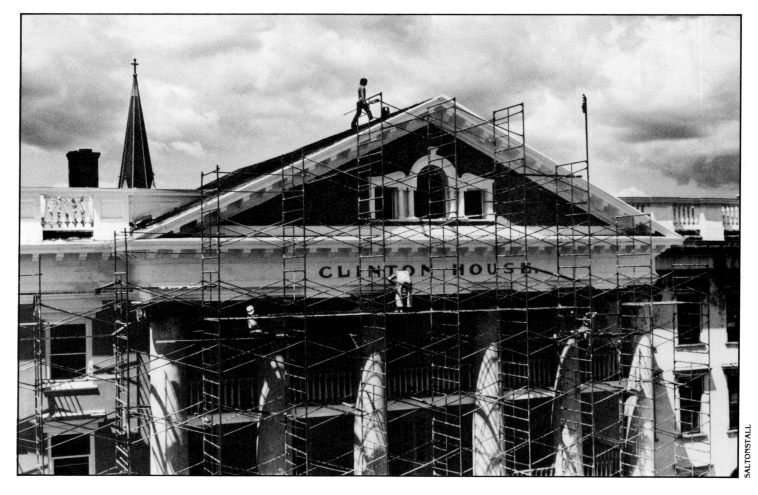

SALTONSTALL

Clinton House, 116 North Cayuga Street

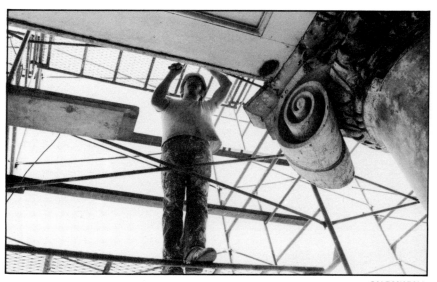

SALTONSTALL

SALTONSTALL

The Clinton House in Ithaca no longer serves the traveling public as a place of "rest and refreshment" but it does remain a "noble landmark." Intrinsically interesting as a fine example of adaptive restoration, it has added importance as the entire first floor houses the museum and offices of the DeWitt Historical Society of Tompkins County.

. . . (The restoration) was a monumental job and could not have been accomplished without considerable volunteer labor. Old and young worked with extraordinary zeal and loyalty to bring the glow of life to the old landmark.

Lois O'Connor
from *A Finger Lakes Odyssey*

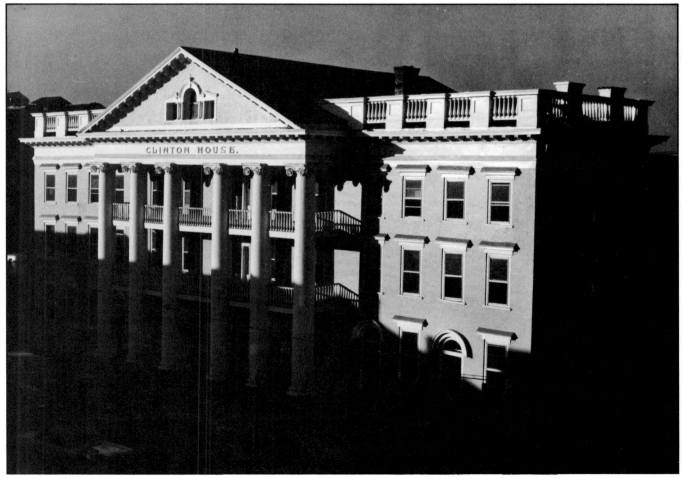

SALTONSTALL

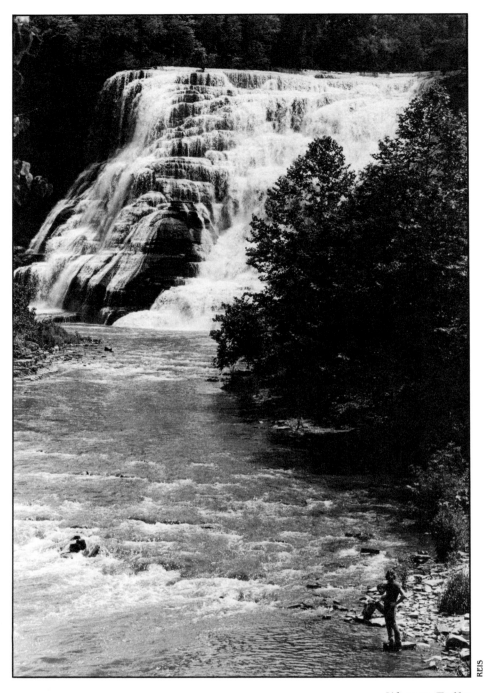

Ithaca Falls

Ithaca Falls, at the western end of Fall Creek gorge, were noted for their beauty year around. Water tumbled down in white foam in early spring, reduced to a trickle in dry weather, and water froze in winter as it cascaded over the long descent of rocks.

Lawrence H. Jacobs
from *Early Boyhood Days in Ithaca*

AUGUST AFTERNOON IN STEWART PARK

The wind pushed the lake towards us.
You told me how the northern end
drops at least a foot on days like this,
when the waves wear white
and the gulls hover at the edge,
refusing to dance over them.
And I felt like a gull,
perched on the pale bleached log
safe and warm beside you,
watching the lake, waiting
for the white to go away
and let our wings float free.

Katharyn Machan Aal

Cayuga Lake

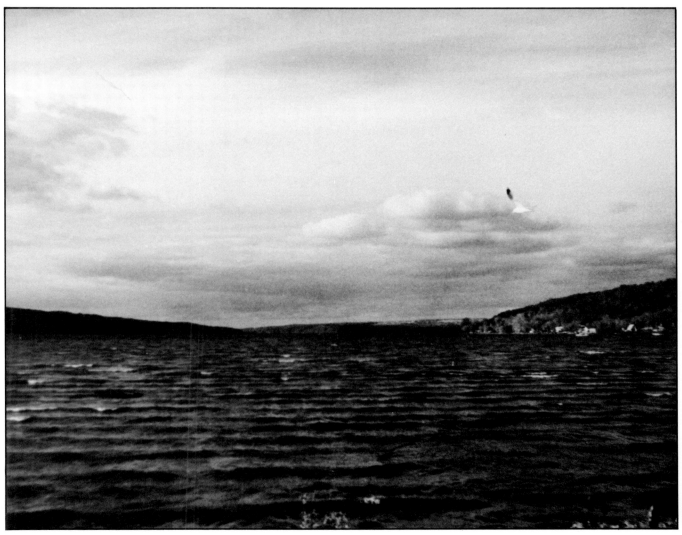

CARREY

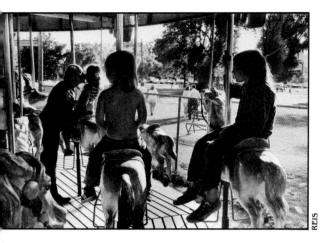
Merry-go-round, Stewart Park

One of the features of my town — Ithaca, New York — that I especially like is Stewart Park, a number of acres at the head of Cayuga Lake. There is a golf course, a beach and bathhouse, tennis courts, a children's zoo with peacocks and monkeys and goats and deer, a pool for fishing and another that is a home for local ducks as well as a resting spot for those in transit; there is a picnic pavillion, a ball field, swings and seesaws. In addition there is a small merry-go-round. . . . And in the summer, no matter where one happens to be in the park, the merry-go-round music can be heard.

James McConkey
from *Night Stand and Other Stories*

Stewart Park

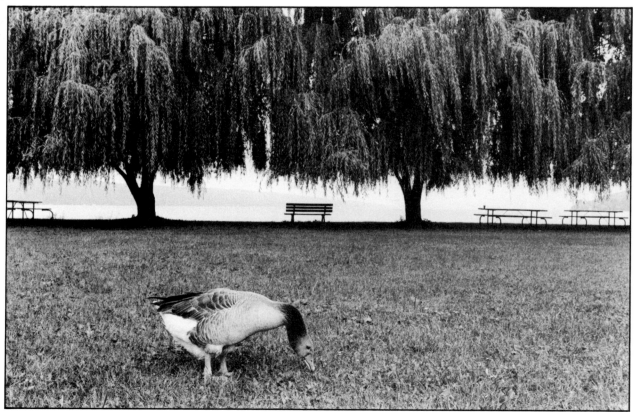

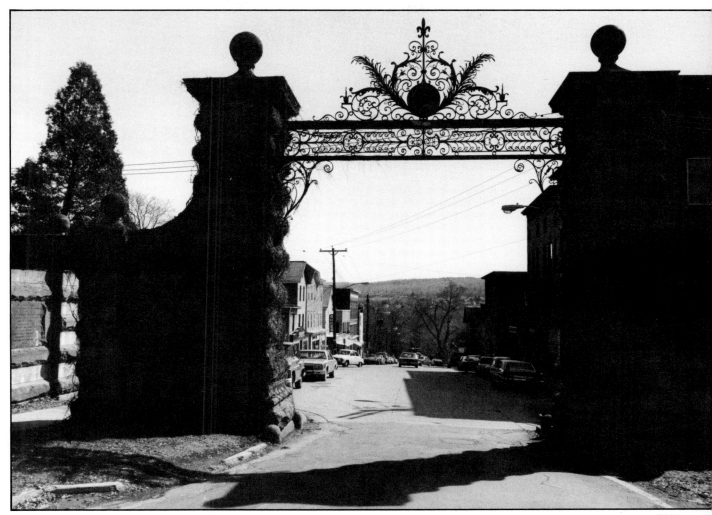

Eddygate, Collegetown

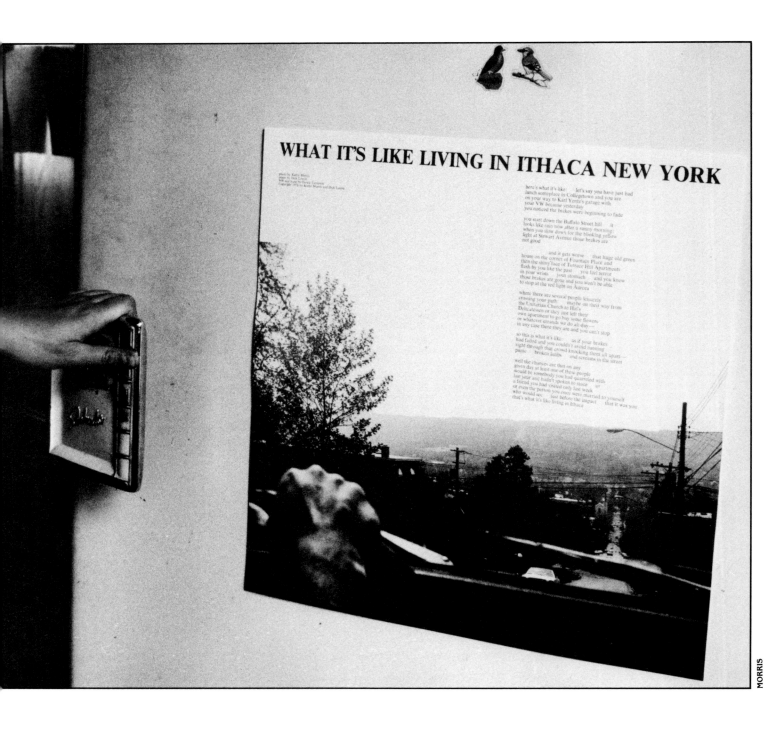

40

Fontana's Shoe
Sales & Rebuilders,
401 Eddy Street

400 College Avenue

413 College Avenue

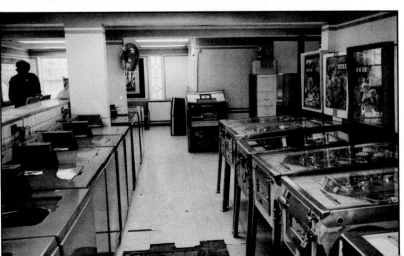

Student Agencies, Inc.,
412 College Avenue

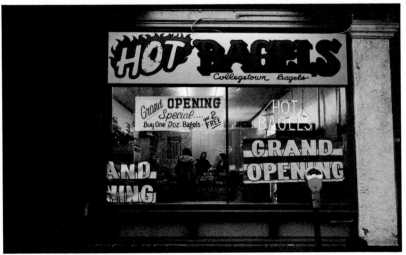

41

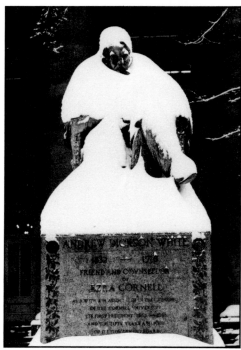

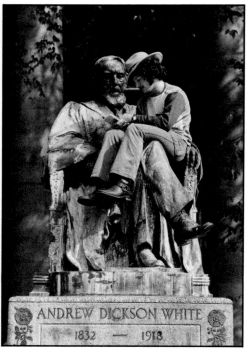

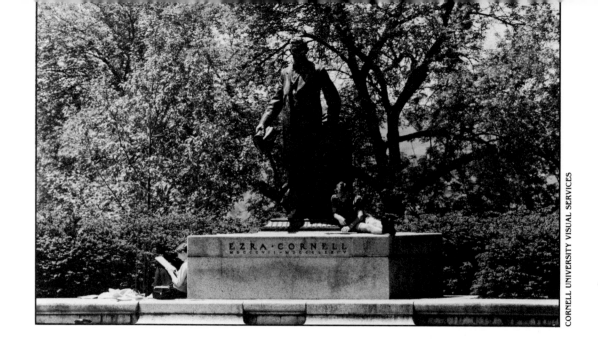

CORNELL UNIVERSITY VISUAL SERVICES

As anybody fond of Cornell knows, the University has a personality — one based to a large degree on the differences between Ezra Cornell and Andrew D. White. Those initial differences continue to produce rivalry between the forces espousing American practicality (the application of knowledge to work) on the one hand, and those espousing a rigorous scholarship based on a European model on the other. It's a wholesome tension, preventing the institution from celebrating either elitism or materialism, and I suspect it is duplicated in the personalities of many of us who now teach and do research here.

James McConkey
from "On Being a Writer at Cornell"

CRISPIN

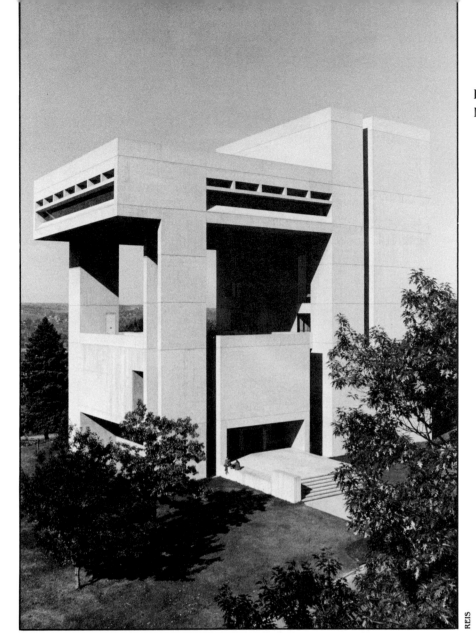

Herbert F. Johnson
Museum of Art, Cornell

REIS

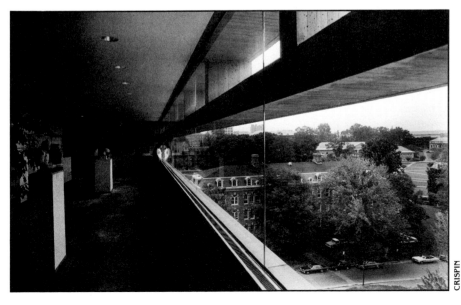

Interior,
Johnson Museum

CRISPIN

Interior, Johnson Museum

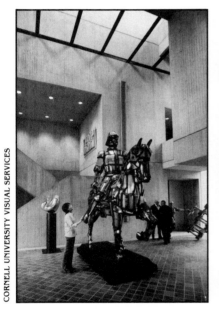

Cornell is not only big and high, it is cosmopolitan and friendly; and it is an infinitely various place.

E. B. White
from *Letters of E. B. White*

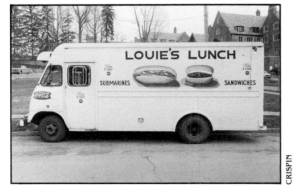

Thurston Avenue

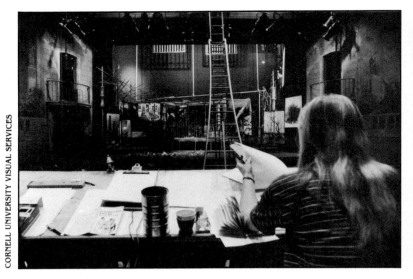

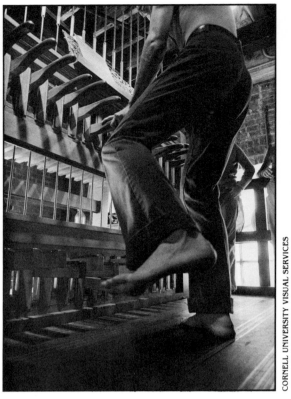

Willard Straight Theater, Cornell

"There's a vitality here, a pool of creative energy, that I've found in few other places. Ithaca is the closest thing to Paradise I've ever experienced."

Douglas Beaver
Architectural Psychologist

Playing the Chimes,
Library Tower, Cornell

Temple of Zeus, Goldwin Smith Hall

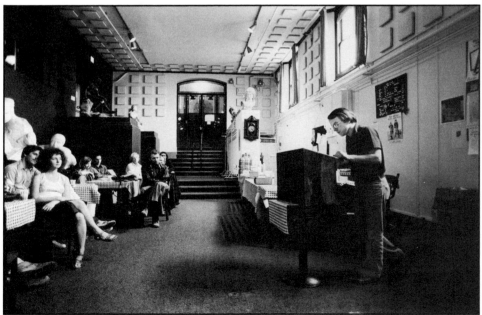

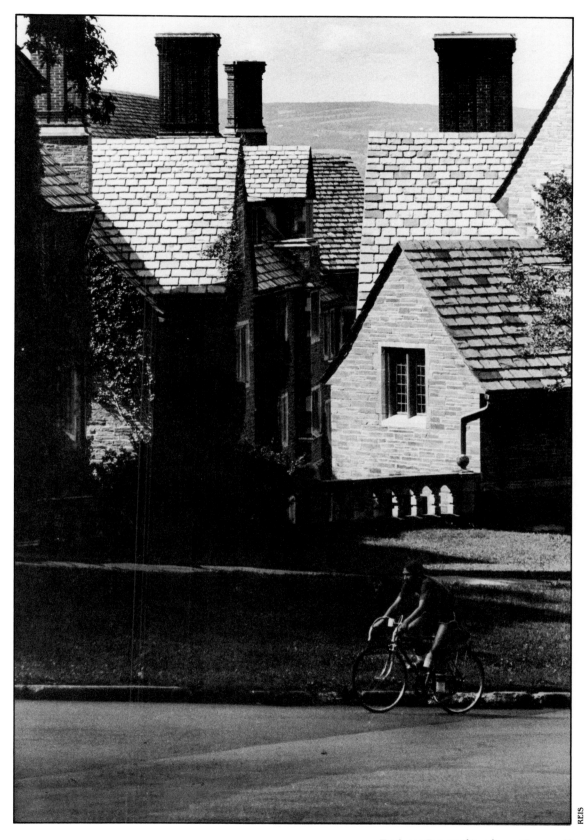

Baker Dormitories, Cornell

REIS

47

Ithaca College is on a hill. Granted, that may not be the most important fact for a prospective student to focus on, but it's inescapably the first fact that hits you when you visit Ithaca College for the first time. Whatever the season. Whatever the time of day. It is some hill. With some view.

Ithaca College Bulletin

Ithaca College

CRISPIN

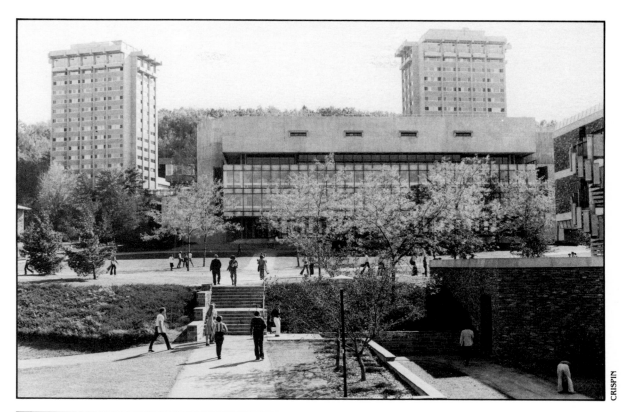

Job Hall, Ithaca College

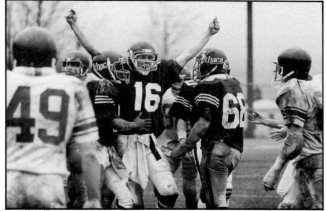

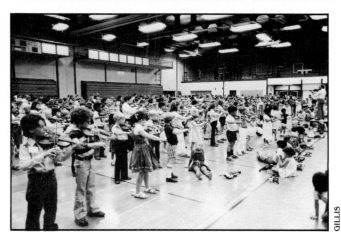

Suzuki Institute, Ithaca College

49

Turkey Hill Road

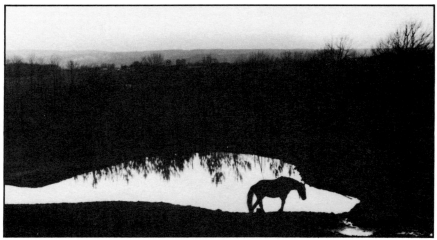

RIVCHIN

The Finger Lakes Region has its own
unique charm — a quality that is easy to
recognize and pleasant to experience, but
difficult to capture in a word. When you
encounter this area and walk its hills, it is like
a chance acquaintance with a stranger who you
immediately sense will become a longtime
friend.

Bill Ehling
from *25 Walks in the Finger Lakes Region*

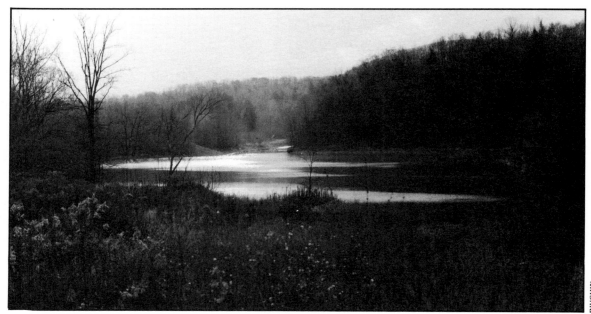

RIVCHIN

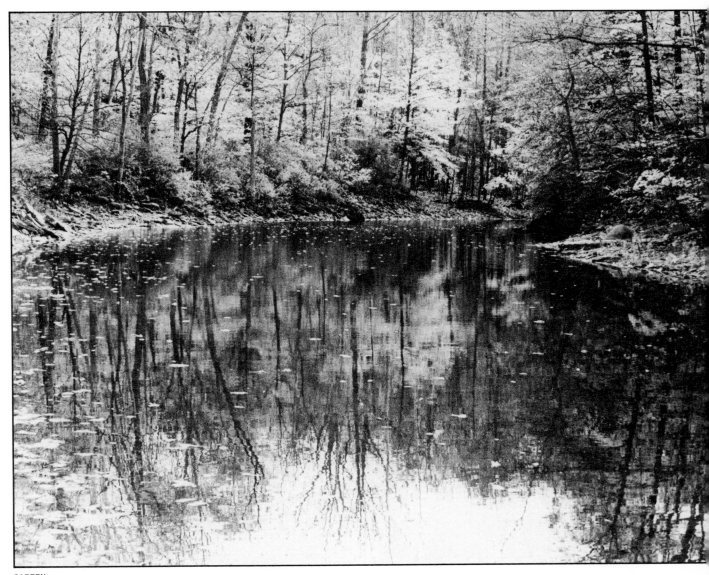

CARREY

Van Natta Dam Watershed

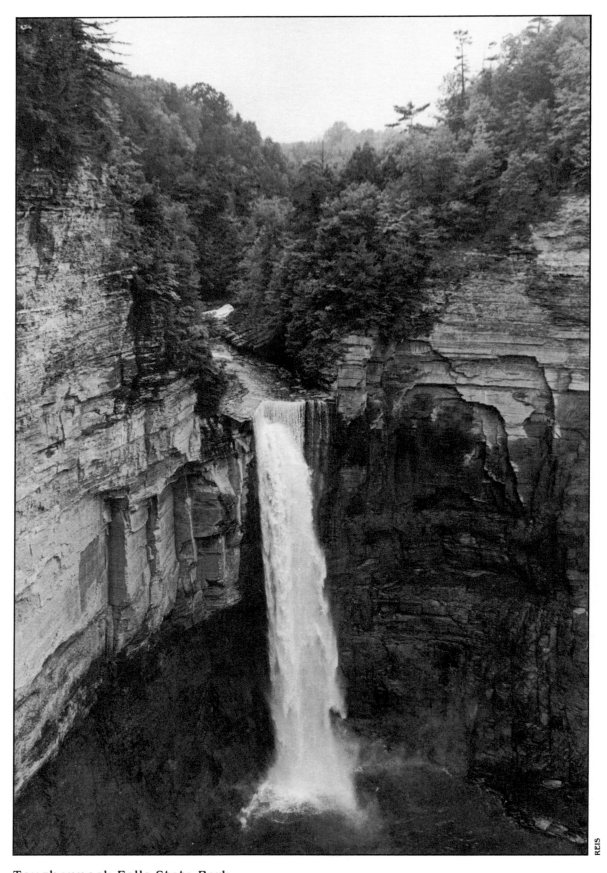

Taughannock Falls State Park

REIS

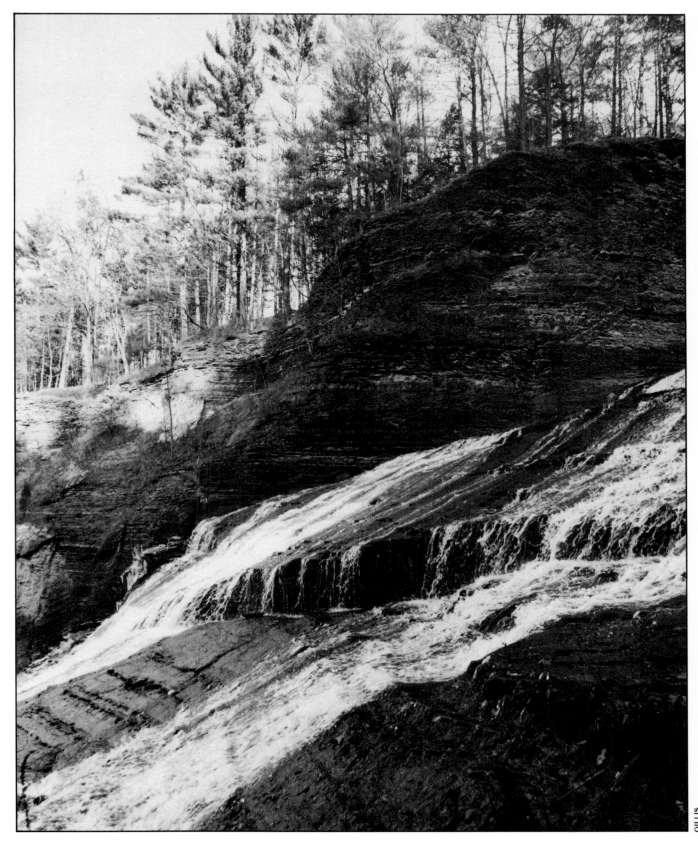

Buttermilk Falls State Park

"I love Ithaca because there's a real nice cross section of all kinds of people. It's a beautiful place to live, both near town and out in the surrounding areas. I've never lived anywhere else for as long a time as I've lived in Ithaca. This is really home."

Kate Mason
Nursing student

West Danby

MORRIS

54

Freeville

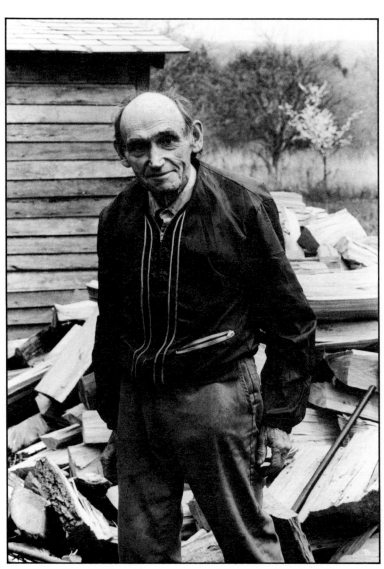

Peruville

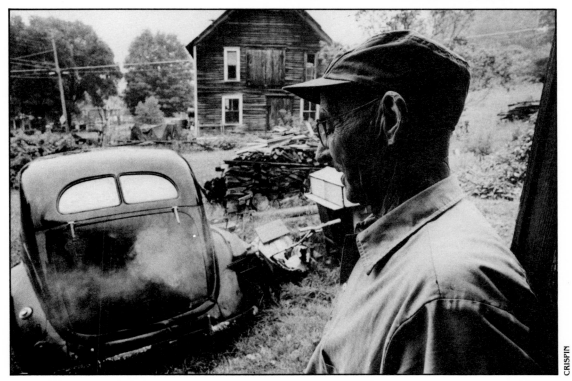

CRISPIN

CRISPIN

55

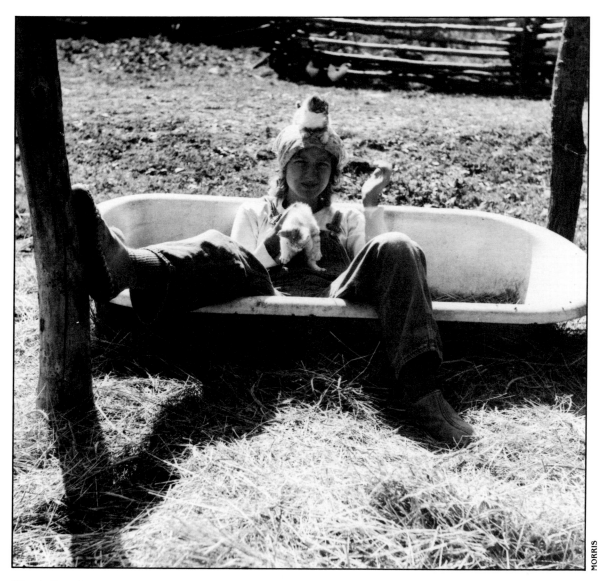

West Danby

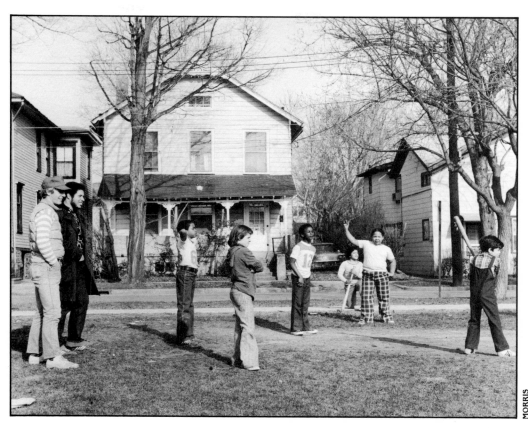

Washington Park Neighborhood

Fall Creek Neighborhood

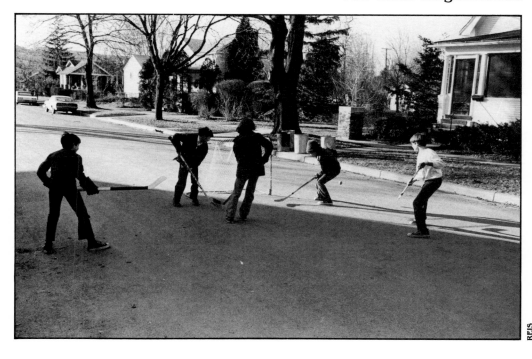

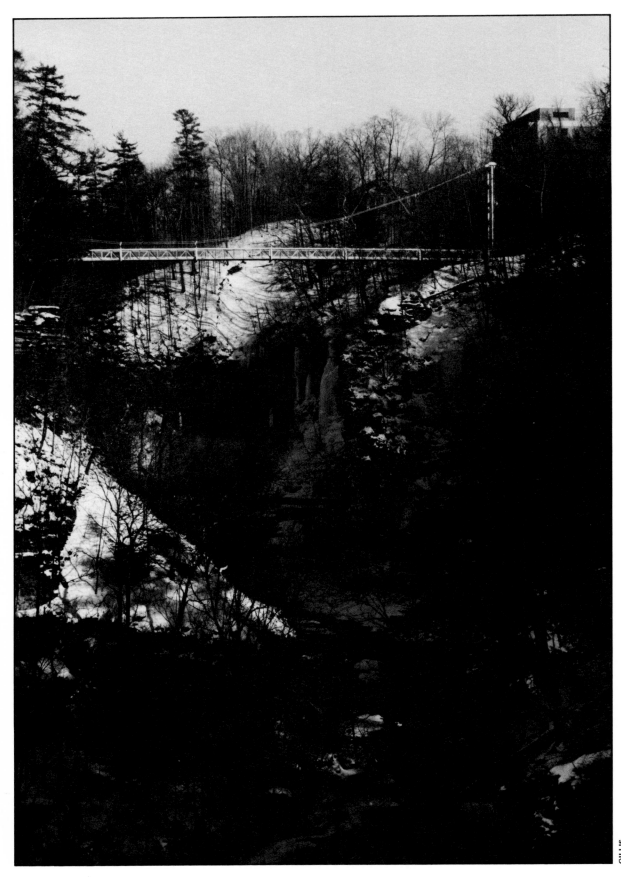

Suspension Bridge over Fall Creek

"I've traveled all over since I was about seventeen and I'm sixty-five years old now. I've been in every state in the Union and I always wind up back here so it must be a good place to live. I like the seasons here. Always changing. You've got at least four a year here."

George Housel
Retired taxicab driver

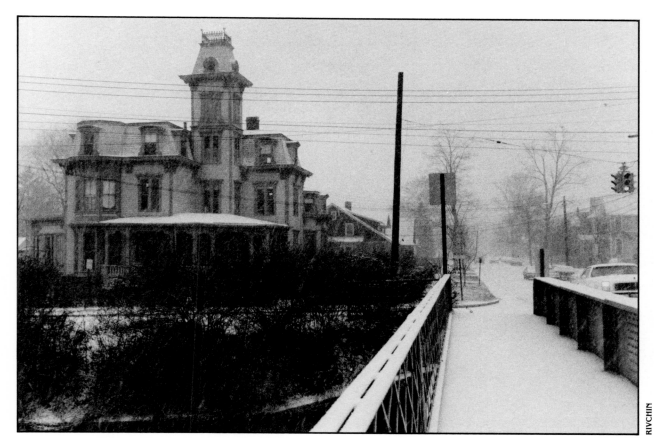

Sprague House in the Snow, South Albany and Titus Streets

Goldwin Smith Hall, Cornell

We flew through a countryside buried under two inches of new-fallen snow. The hills, all bonneted, were like little alps; and toward twilight, everything turned blue — hills, snow and sky. . . . We were in Ithaca.

E. B. White
Letters of E. B. White

Seely's Apple Orchard, West Danby

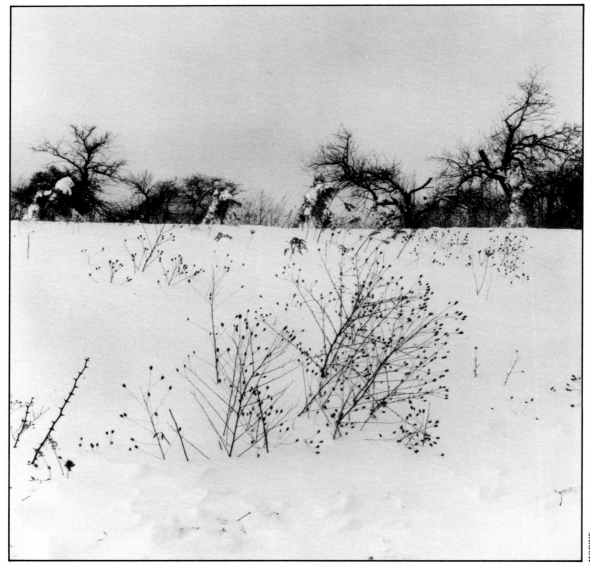

MORRIS

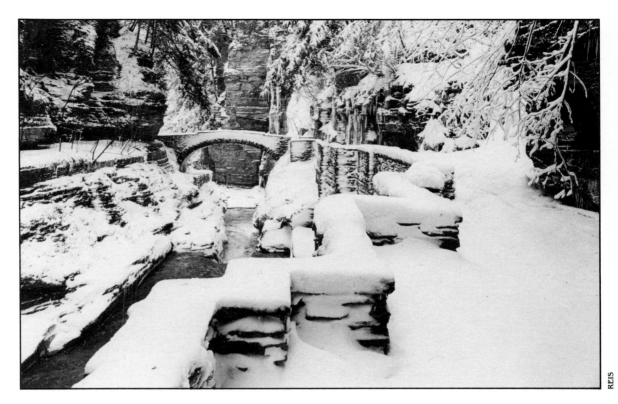

REIS

Robert H. Treman State Park, Enfield

Hydraulics Lab, Fall Creek Gorge

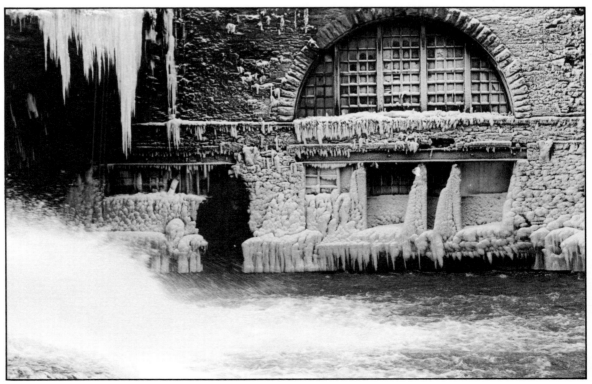

REIS

"In the wintertime Ithaca really comes into its own: thriving, bustling, cheeks rosy and noses very, very cold. The snow and the students are everywhere, and the car won't start, and you can ski from your door into the wilderness. The ice skaters, the tray-sliders, the sweat-suited joggers abound. You can watch frozen waterfalls and wait in line all night for hockey tickets and laugh at elves on the Commons. Oh, there's no question in winter: this is Ithaca!"

Cyndy Scheibe
Director, Fancy Free Clowns

Cayuga Nature Center

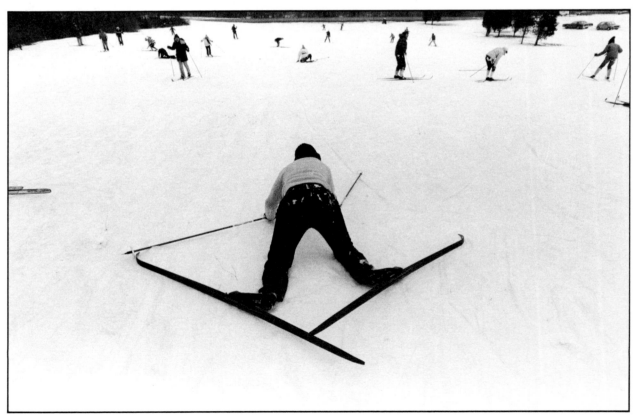

CRISPIN

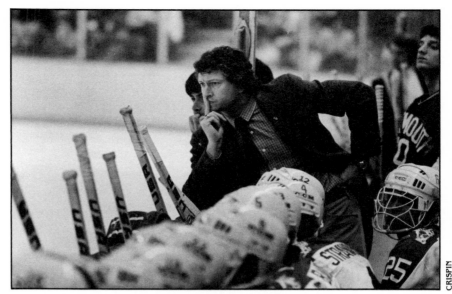

CRISPIN

Lynah Rink, Cornell

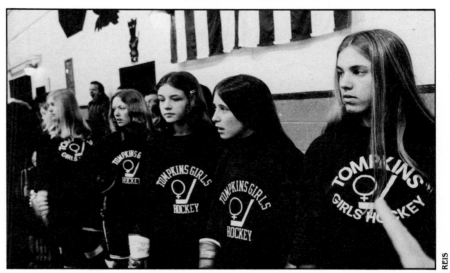

REIS

Lynah Rink, Cornell

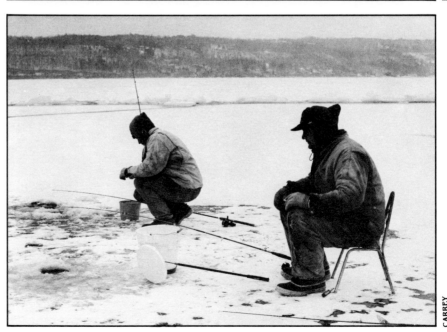

CARREY

Cayuga Lake

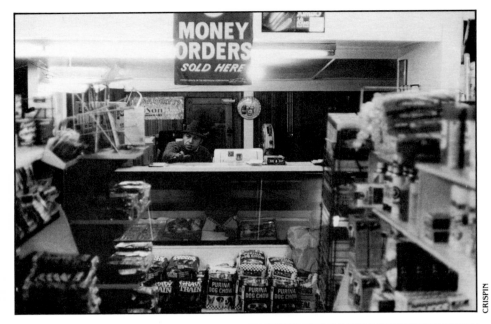

Jake's Red & White Store,
402 West Court Street

CRISPIN

Agway Lawn & Garden Center,
213 South Fulton Street

CRISPIN

Andrews' Confectionary,
308 East State Street

REJS

CRISPIN

REIS

My friends, let us ask openly
for what we need
we will have enough
for each other.

Peter Fortunato
from "9 December 1979"

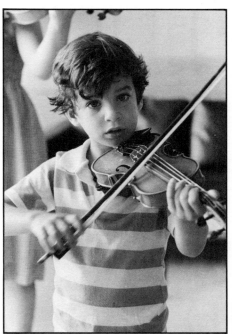

CRISPIN

"There is such a diversity of people seeking Truth in so many different ways, and they all have a high degree of tolerance for one another. There is also a lot of creative activity in Ithaca, on all levels. There is an appreciation of beauty here."

Mark Klempner
Songwriter and guitar teacher

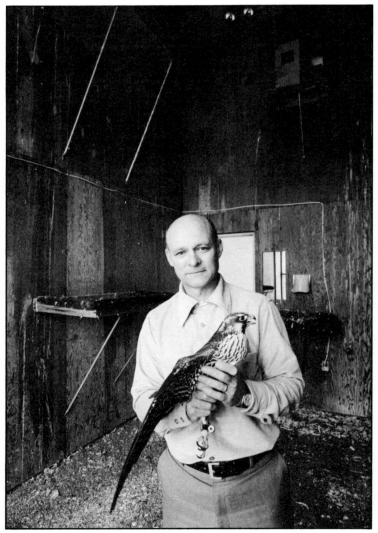

REIS

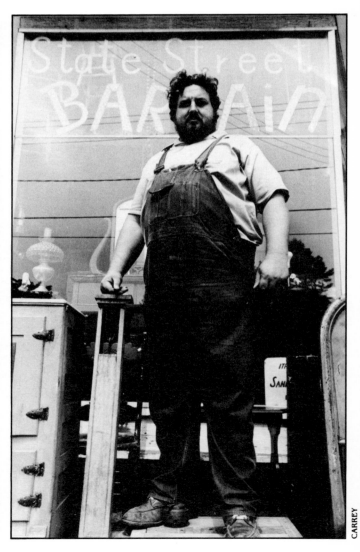

CARREY

66

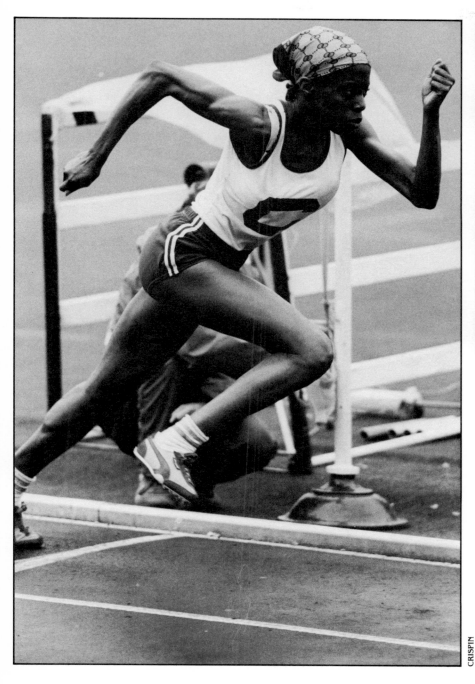

CRISPIN

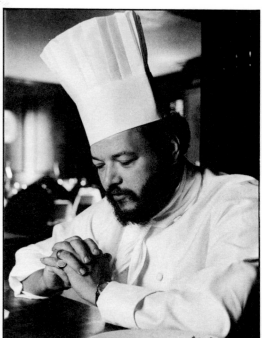

CARREY

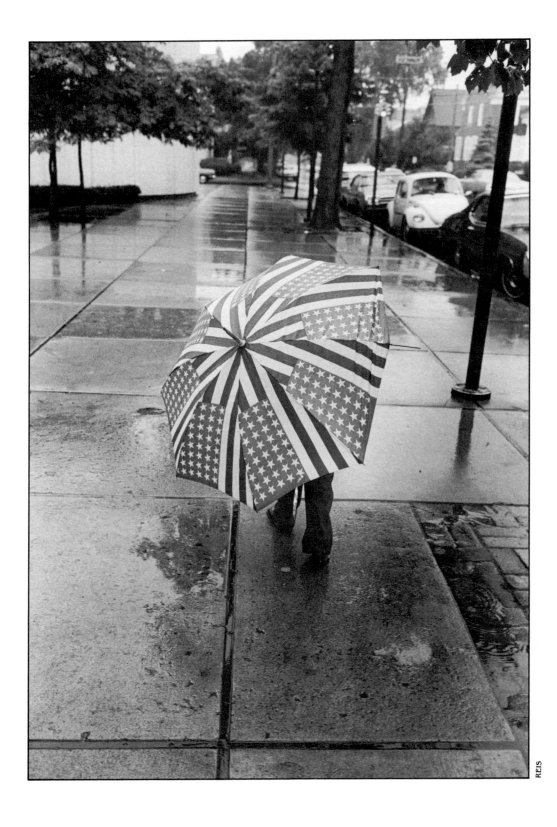

REIS

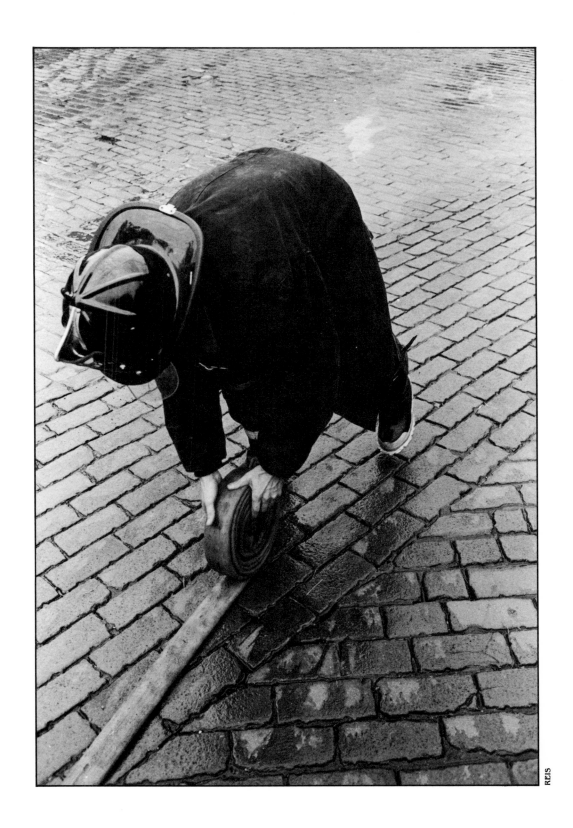

REIS

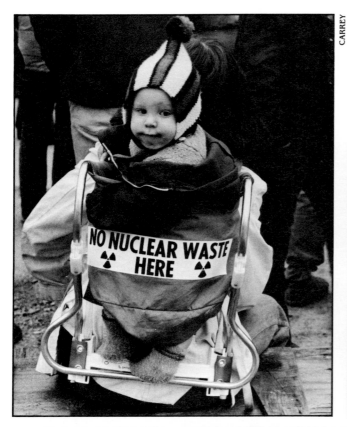

CARREY

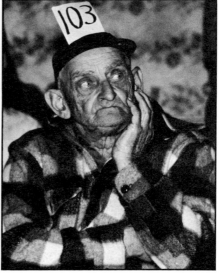

CARREY

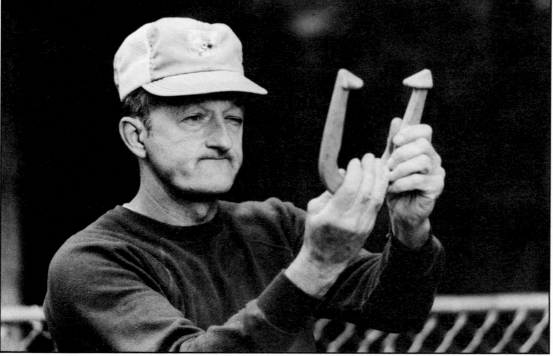

CRISPIN

70

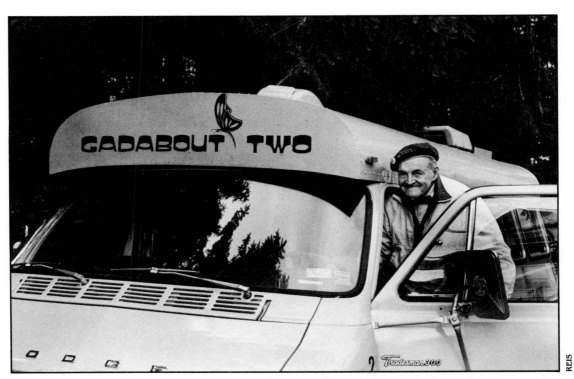

REIS

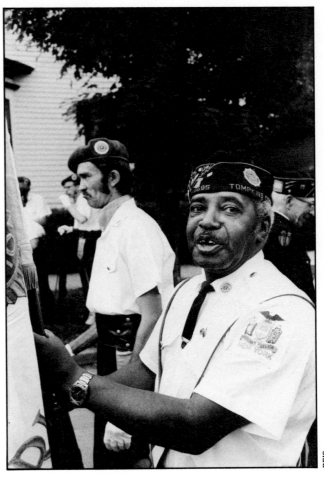

REIS

My heart is an Ithaca spring,
each day different.

Layle
from "Come With Me"

Stewart Park

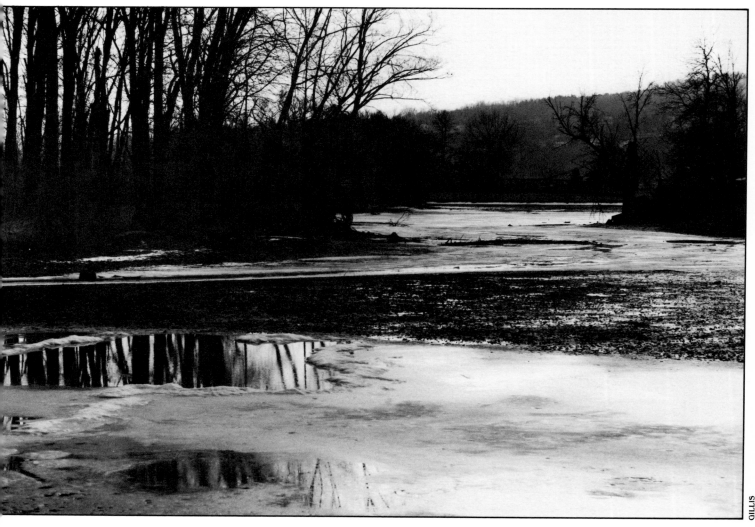

GILLIS

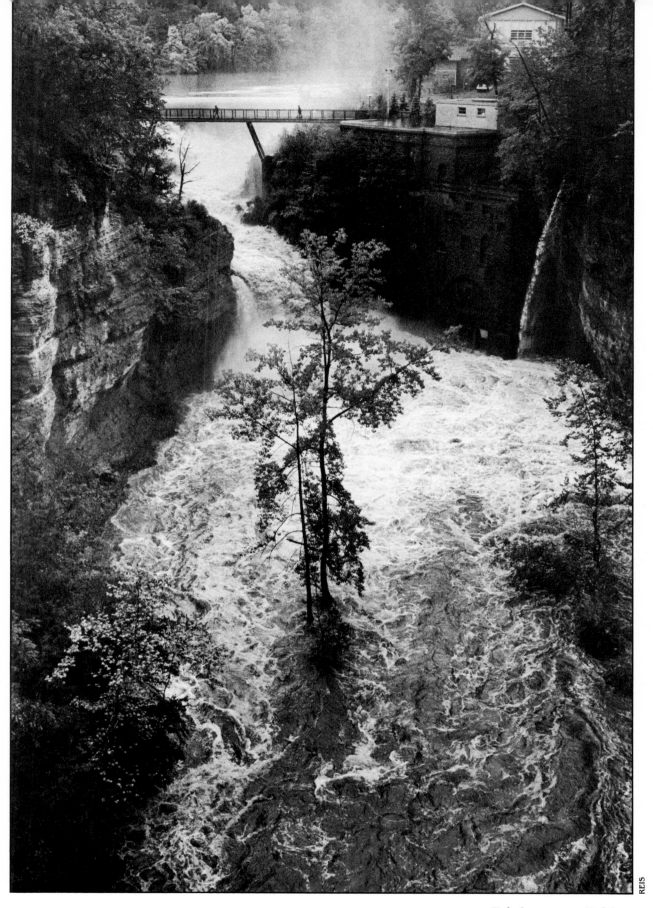

REIS

Triphammer Bridge

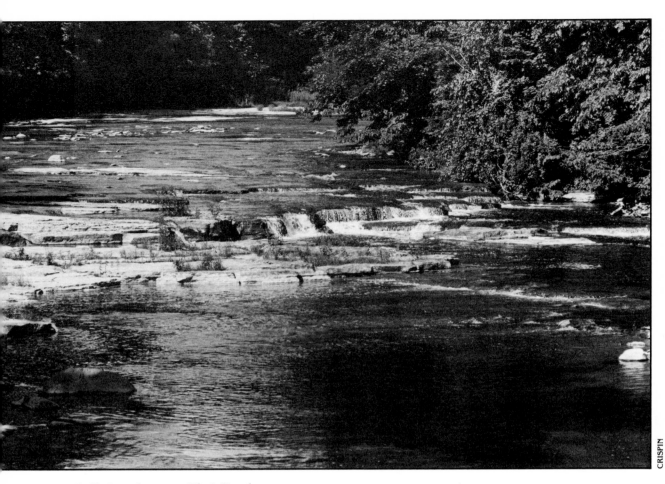

CRISPIN

Fall Creek near Flat Rock

West Danby

MORRIS

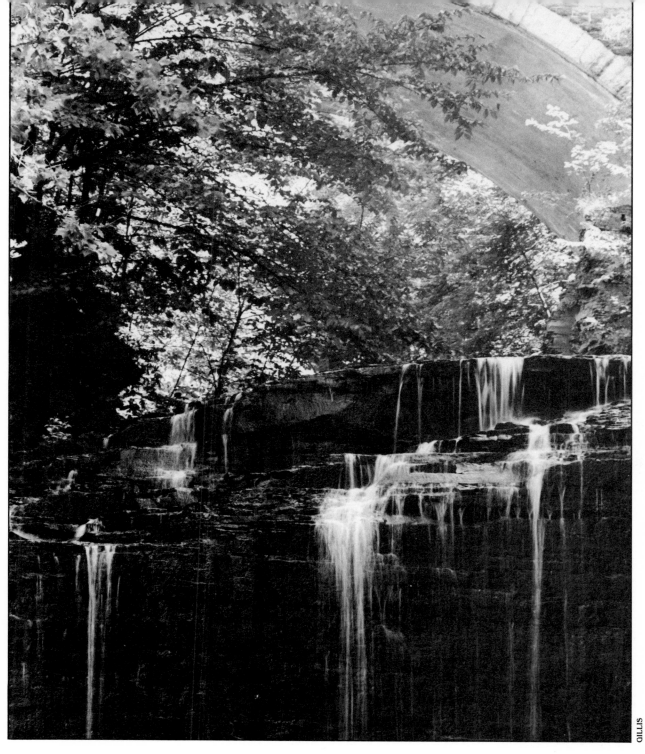

Cascadilla Gorge

among thousands of
streams of water,
your voice can find its own timbre,
your feet, their own steps.

Mary Gilliland
from "First Born Steps"

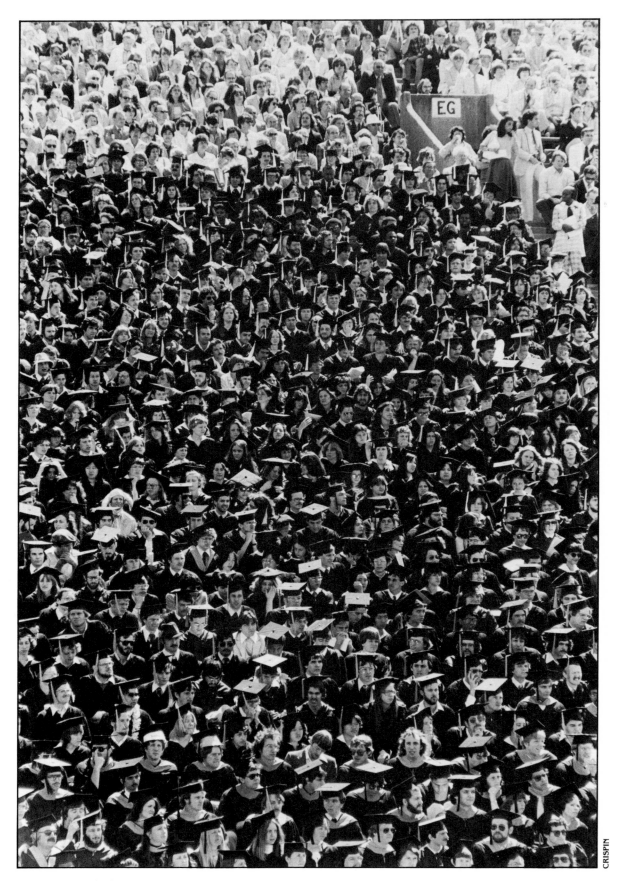

Schoelkopf Field, Cornell

Ithaca, I'm almost on my way.
Your creeks run westward, and I've always
 wondered
what lay on the far side of your hills.
Surely a tougher hill, a tougher race of people.
But I promise you this, pretty town,
since you've given me such a bouquet:
I'll be bowing out backwards down Buffalo
the rest of my life.

Abby Rosenthal
from "To Ithaca"

Ithaca from West Hill

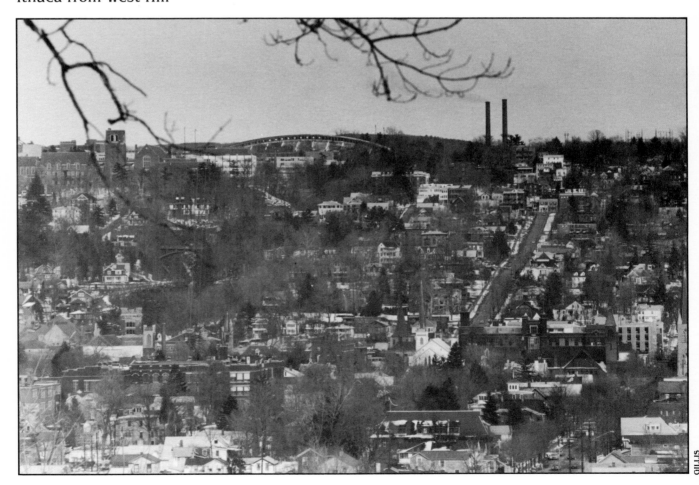

GILLIS

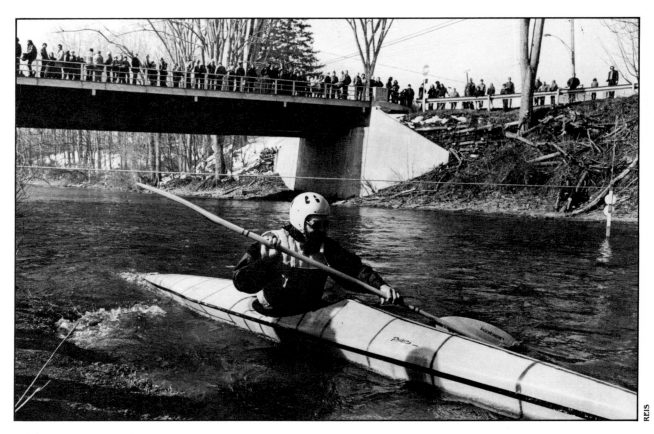

White Water Derby, Fall Creek

"Anything That Floats and Isn't a Boat" Race

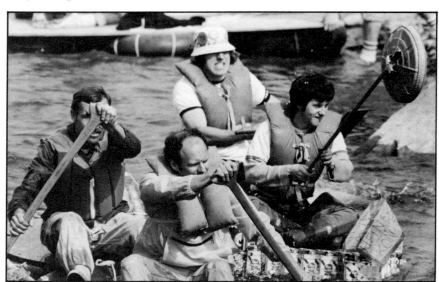

When a shell and its straining oarsmen
crossed the finish line a length, or barely ahead
of its nearest competitor, excitement ran high.
Cheers and the sound of horns blowing filled
the air, more loudly when the home crews won.

Lawrence H. Jacobs
from *Early Boyhood Days in Ithaca*

Intercollegiate Crew

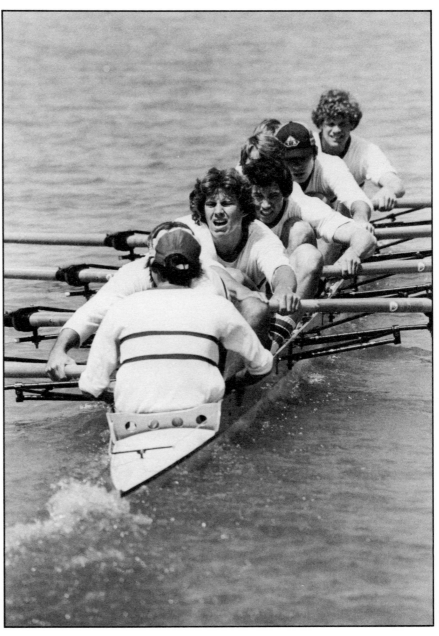

CRISPIN

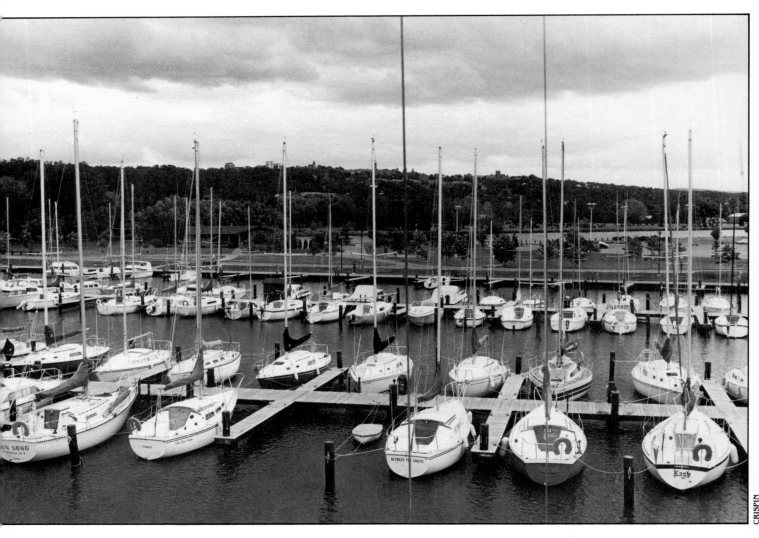

Allan H. Treman State Marine Park

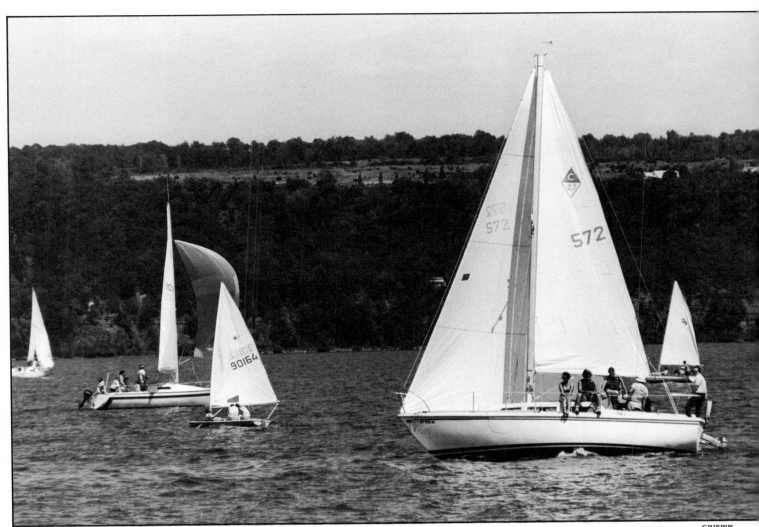

CRISPIN

Cayuga Lake

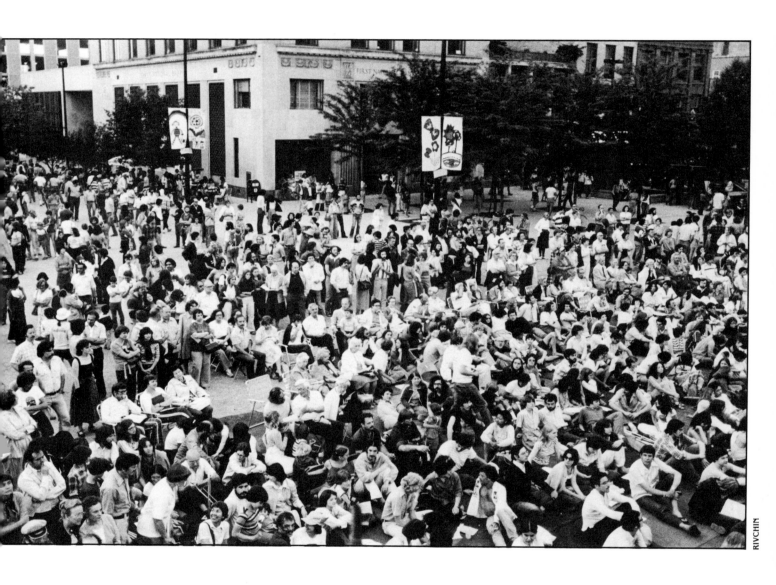

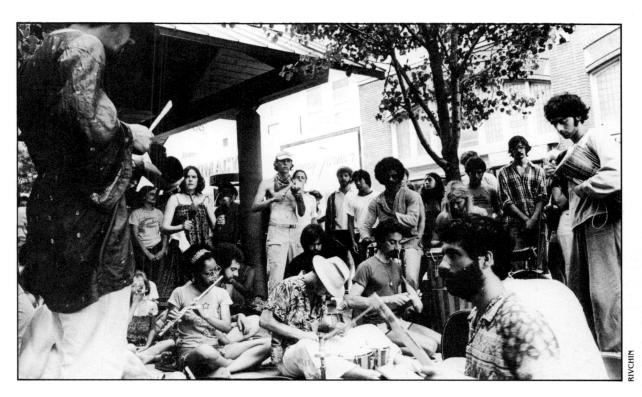

Ithaca Festival, Ithaca Commons

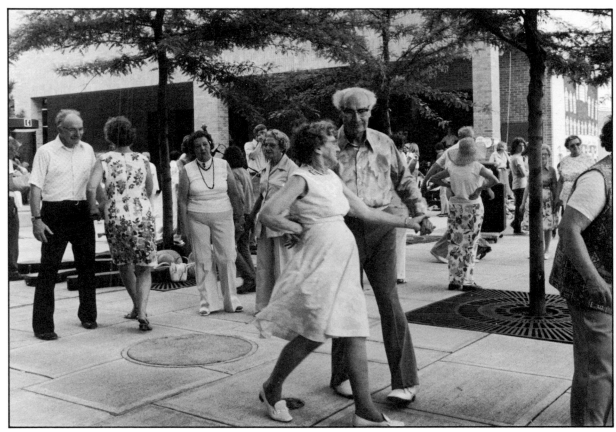

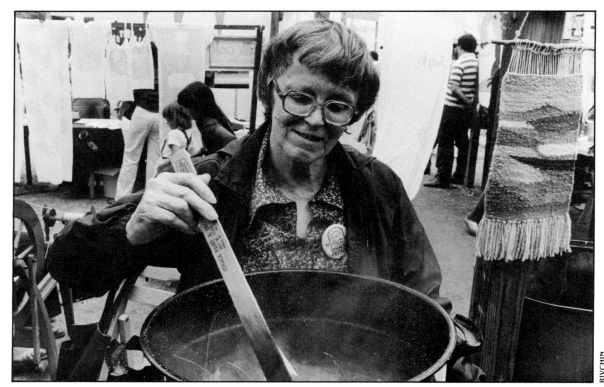

RIVCHIN

CARREY

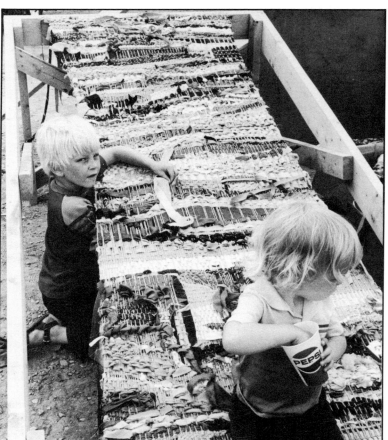

RIVCHIN

"The Festival made me realize that I was part of a bigger neighborhood, that all the people who were dancing and playing and blowing giant bubbles were part of the same kind of unit and the event symbolized that unity. It made me feel I had walked into a party and maybe I was the guest of honor. The Festival offered that kind of welcome to everyone in the city. . . . All of a sudden, I felt I was really part of this town."

Jan Conrad
General Coordinator, Ithaca Festival 1980

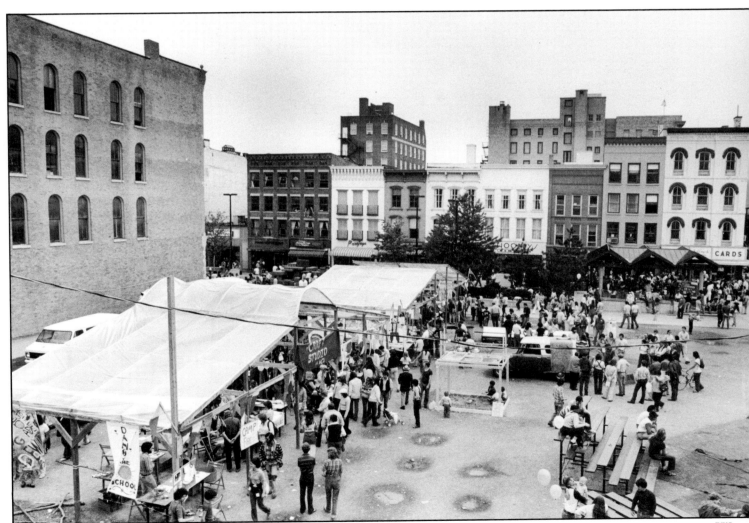

REIS

Cass Park

CARREY

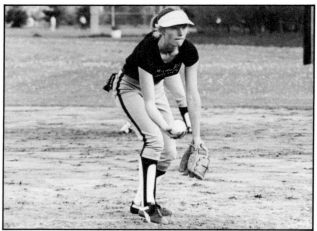

CARREY

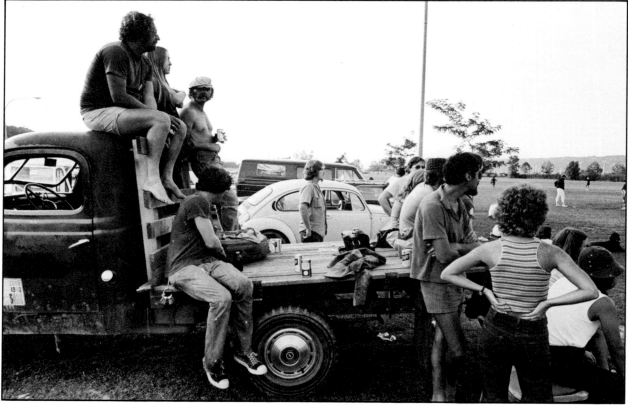

REIS

"This is my 25th year living in this vicinity. I like the University. I like the hill sights from where you can see all of Ithaca. And I like the Cass Park area very much where the ball games are."

Rev. King Hardy, Jr.
Retired

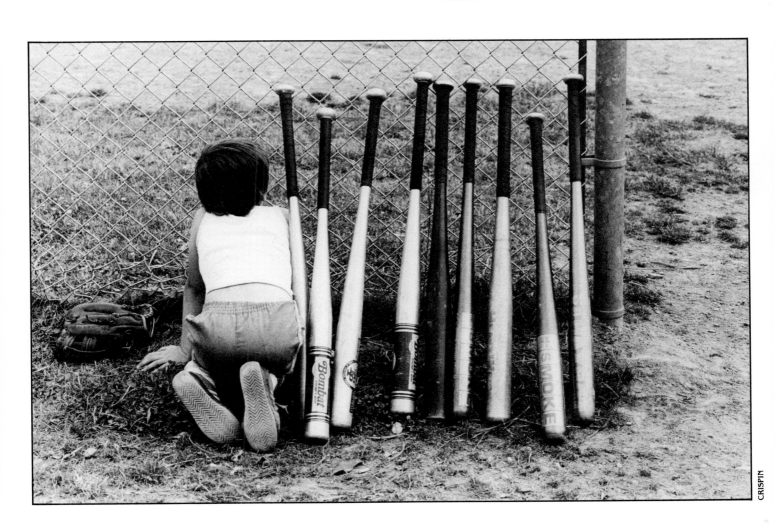

CRISPIN

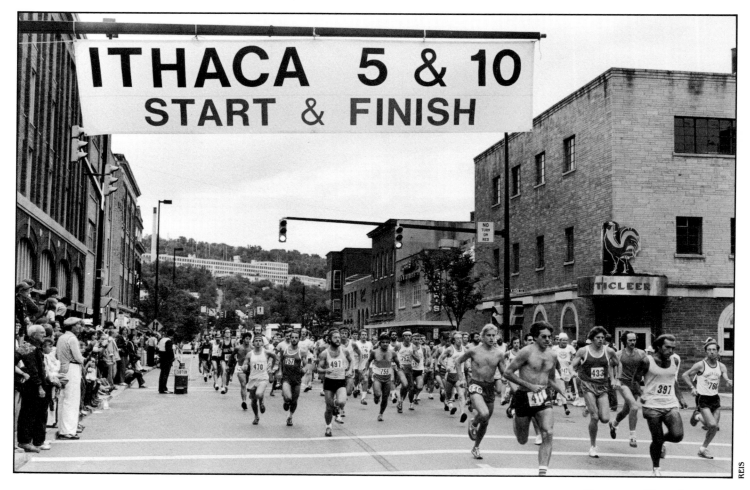

Cayuga Street

"Having its debut in 1975, the Ithaca 5 & 10 was founded to commemorate the Commons with a spectacular sporting event and to provide Ithacans with their first city road races . . . a 5 and a 10 mile run.

"The '5 & 10' opened with a bang. On its very first year over 150 participated and soon the number exploded to over 500 runners as more and more locals and many out-of-towners learned of its popularity and success. It is now Ithaca's largest annual participatory sporting event."

Jim Hartshorne
Founder, Ithaca 5 & 10
and the Finger Lakes Runners Club

The land isn't too poor, but it's certainly no
 open fields of grass.
It has in it grain and wine beyond a god's
 power to express,
And it always gets rain and dew to make
 things bloom,
A good place to raise goats and cattle,
There's timber of every kind and the watering
 holes are full year round.
For this reason, stranger, the name of, yes,
 Ithaca, has made its way even to Troy.

Homer
from *The Odyssey*, Book XIII: lines 243-248

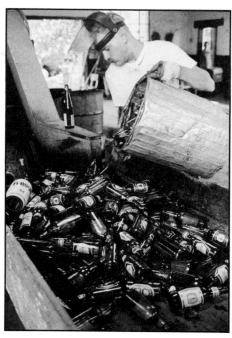

Glass Recycling Center,
Challenge Industries

North Aurora Street

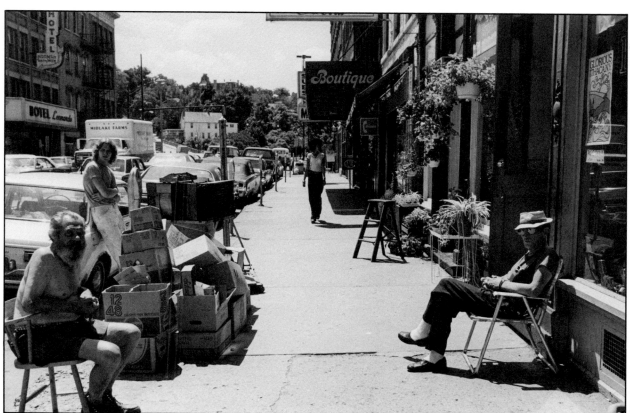

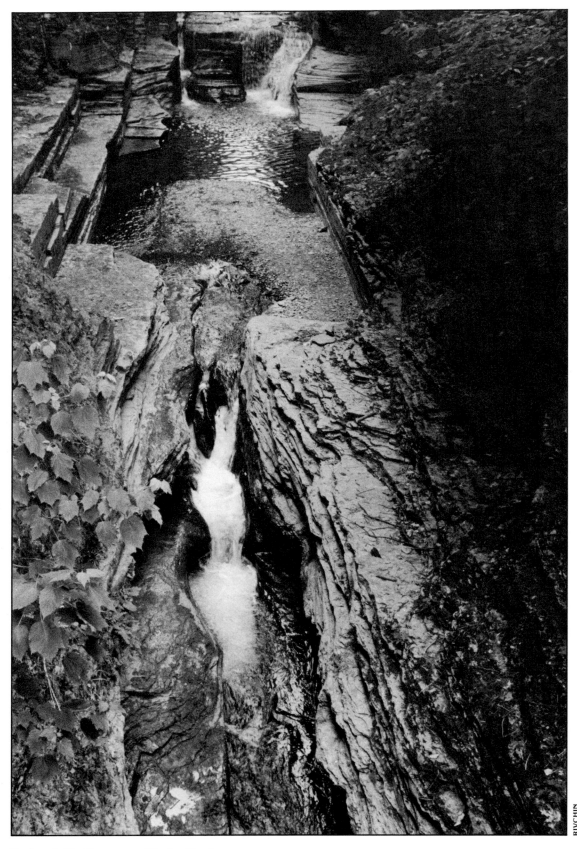

RIVCHIN

Robert H. Treman State Park

Respectful of the millenia, I tread
the valley's upward path,
behind me the fossil pool,
the eroding fields.

Pindie Stephen
from "Upper Treman"

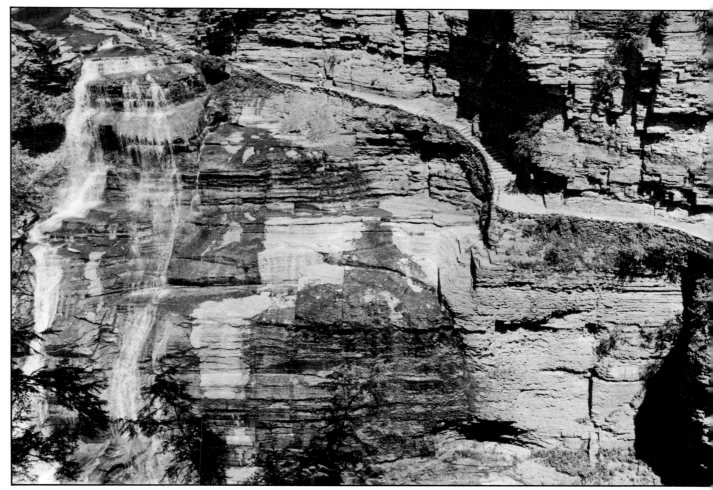

Treman Park

RIVCHIN

and I love it, this land and water
I cross, blessing all
and myself with it, blessed
though I am lost
flowing always
away from myself

Peter Fortunato
from "9 December 1979"

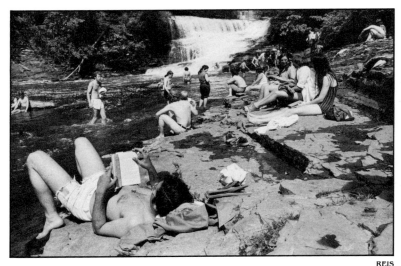

Beneath the Suspension Bridge

REIS

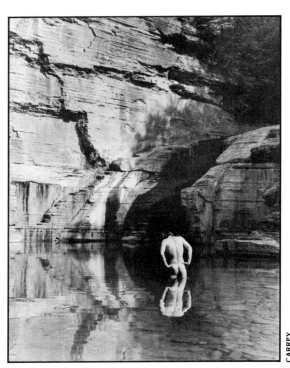

CARREY

Potter's Falls, Six Mile Creek

Treman Park

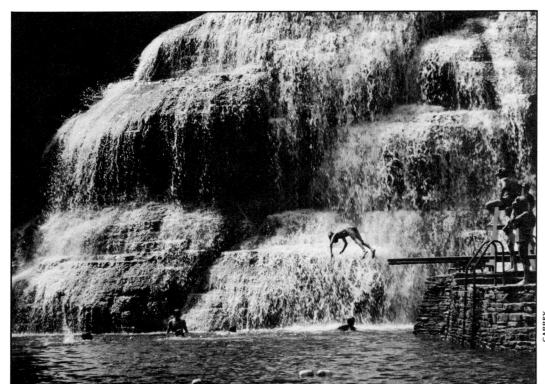

CARREY

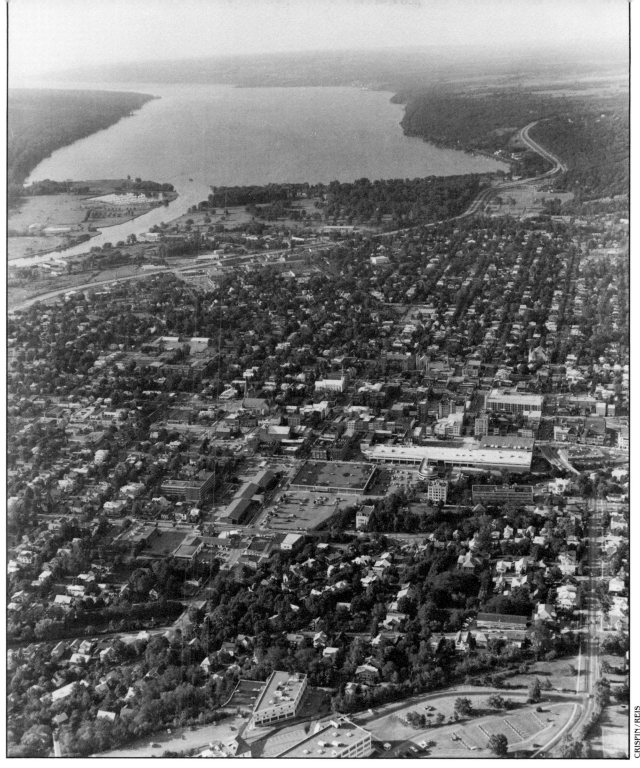

Ithaca

CRISPIN/REIS

I make my home in Ithaca — you can see it
 clear against the afternoon sky.
. . . And I myself
 can never set eyes on
Anything sweeter than this land.

Homer
The Odyssey, Book IX: lines 21, 27-28

Biographical Notes

Nancy Carrey

Kathy Morris

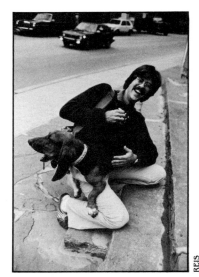

Jon Crispin

Andrew Gillis

Nancy Carrey, a resident of Ithaca since 1971, has worked as a free-lance photographer for the *Good Times Gazette* and as staff photographer for the *Ithaca Times.* Her work has appeared in *The Village Voice, Downbeat Magazine* and *Letters to Tiohero.* She is primarily interested in photojournalism, documentary photography and people.

Jon Crispin is a commercial photographer who has lived in Ithaca since 1974. He holds a Bachelor of Fine Arts degree from Wittenberg University and is currently working on several continuing photographic projects.

Andrew Gillis is a native Ithacan and a graduate of Cornell University. He has been involved in photography and film making for over 10 years, has had several one-man shows of his work, and has participated in many group shows at local and regional galleries. His film credits include sound recording for *Until I Get Caught* and assistant director for *Two Ball Games.*

Kathy Morris lived in Ithaca for eight years. During that time, she worked at Moosewood Restaurant, received an M.F.A. from Cornell, and sold organic vegetables at the Farmers' Market. She currently teaches and free-lances in New York City, and comes back to Ithaca for a breath of fresh air as often as possible.

Jon Reis has been doing free-lance photography in the Ithaca area since 1973. He received a B.A. degree from Ohio Wesleyan University and was one of the founding members of STILLS, The Photography Gallery in 1975. He has published *The Halloween Book* and is a co-publisher of *Images,* a photography tabloid. He received a grant from Light Work photographic workshop in Syracuse in 1979 and currently has numerous ongoing photographic projects.

Jon Reis

Constance Saltonstall

Marilyn Rivchin is a photographer, film maker and teacher who studied art history at Barnard College and Cornell University and film making at U.C.L.A. She worked for seven years as a museum curator and was Assistant Director of the Johnson Art Museum until 1974 when she shifted careers to travel and photograph in Haiti. There she was co-director and cinematographer for a documentary film of a village development project, "Saint Soleil: Art for a New Life," made for the U.N. Habitat Conference in 1976. Since then she has taught photography at Ithaca College and Cornell, has had two one-woman exhibitions, has made videotapes on dance, and participated with three other Ithaca women to produce the *Ithaca Everyday Calendar*. In 1978 she cooperated in filming "Kay Sage," a documentary about the American surrealist painter and poet. Currently she makes her living as a lecturer in film making at Cornell and as a free-lancer in several media.

Marilyn Rivchin

Constance Saltonstall has lived in the Ithaca area most of her life. Since 1967, she has worked as a designer and photographer, actively involved in the preservation and rehabilitation of older architecture in Tompkins County. Her interest in photography grew out of a need to document this work in progress, and more recently has become a full-time occupation.

Andrea Fleck Clardy is a writer and editor who has lived in Ithaca for three intense years. Her previous publications include weekly editorial columns in the *Ames* (Iowa) *Daily Tribune*, numerous articles in regional and national magazines, and *Gordon Gammack: Columns From Three Wars* (Iowa State University Press, 1979) which she edited. Educated at Swarthmore College and Harvard University, she is married to Jon Clardy, Professor of Chemistry at Cornell, and is the mother of two sons, Peter and Benjamin.

Andrea Fleck Clardy